P9-DOC-039

# Visions of New York State

*Support for this publication was provided in part by*

Wilson Greatbatch, Ltd.

KeyBank

*and the following individuals and organizations*

Ami and Warren Greatbatch
Joseph G. Tantillo, Sr.
1843 Central Avenue Associates
   Doris P. Fischer, Stewart C. Wagner
Patrick and Mary Ann Mahoney
David A. Wolfe
Joanne Bucci
Robert and Mary Alice Bouchard

# Visions of New York State

## THE HISTORICAL PAINTINGS OF L.F. TANTILLO

L.F. Tantillo

*with introduction by*
Warren Roberts

*with essays by*
Stefan Bielinski
Shirley W. Dunn
Charles T. Gehring
Wendell Tripp

*with contributions by*
David R. Gould
Paul R. Huey
Philip Lord, Jr.
Roger W. Mabie
Joseph F. Meany

*organized by the*
University Art Museum
University at Albany, State University of New York

SHAWANGUNK

The Shawangunk Press
Wappingers Falls, New York

For Corliss

Exhibition dates:

University Art Museum
University at Albany, State University of New York
September 7, 1996-November 3, 1996

Exhibition organized by Marijo Dougherty, Museum Director, and designed by Zheng Hu, Museum Designer.

*VISIONS OF NEW YORK STATE: The Historical Paintings of L.F. Tantillo.* Copyright © 1996 by Leonard F. Tantillo. All rights reserved. Printed in the United States of America. No part of this book may be used or reproduced in any manner whatsoever without written permission from the publisher except in the case of brief quotations for purposes of review. For information write to the Shawangunk Press, 8 Laurel Park, Wappingers Falls, NY 12590.

Designed by Joe Tantillo

Printed by Fort Orange Press, Albany, New York

Library of Congress Cataloging-in-Publication Data

Tantillo, Leonard F.
    Visions of New York State : the historical paintings of L.F. Tantillo / L.F. Tantillo ; with introduction by Warren Roberts ; with essays by Stefan Bielinski ... [et al.] ; with contributions by David R. Gould ... [et al.] ; organized by the University Art Museum, University at Albany, State University of New York.
        p.   cm.
    Catalog of an exhibition held at the University Art Museum, University at Albany, State University of New York, Sept. 7–Nov. 3, 1996.
    Includes bibliographical references and index.
    ISBN (invalid) 1-885482-05-X (cloth : alk. paper). — ISBN 1-885482-05-1 (pbk. : alk. paper)
    1. Tantillo, Leonard F.--Exhibitions.  2. New York (N.Y.) in art--Exhibitions.
I. Bielinski, Stefan.  II. Gould, David R.  III. State University of New York at Albany. University Art Museum.  IV. Title.
ND237.T347A4  1996
759.13--dc20                                                          96-26068
                                                                      CIP

                                                          AC

Cover painting:
*Buffalo Harbor, 1847*
(From the collection of KeyBank)

# CONTENTS

Bruce and Ellen Allen

Christopher L. Anderson

Norman Bauman

Stefan Bielinski

Robert and Mary Alice Bouchard

Kenneth Bradt

Karen Engelke

Cheryl and Charles Fangman

Michael and Sharon Fernandes

Charles T. Gehring

Ami and Warren Greatbatch

The Hudson River Club

William and Michele Keleher

KeyBank

Roger W. Mabie

Patrick and Mary Ann Mahoney

James and Dolores Miller

Michael B. Picotte

Thomas and Mary Rabone

Victor and Lyn Riley

Patricia Roberts

Mark and Kim Rossman

Bill and Mary Ellen Siebert

David and Mary Smith

Corliss R. Tantillo

Edra M. Tantillo

Joseph G. Tantillo, Sr.

Wenonah K. Tantillo

David N. Toussaint

Francis H. Trombly, Jr.

Pieter S. Vanderzee

David and Barbara Van Nortwick

Lois and Stewart Wagner

Richard and Ellen Whipple

David and Mary Carol White

Wilson Greatbatch, Ltd.

David A. Wolfe

The exhibition "Visions of New York State: The Historical Paintings of L.F. Tantillo" is an opportunity to share with our museum's visitors the fascinating and moving stories of the unique history of this great state, particularly of the region located at the confluence of two of America's most important rivers—the Mohawk and the Hudson.

The paintings presented in this exhibition have a powerful popular appeal and validate the artist as a masterful storyteller with a formidable artistic talent. Each work is imbued by the artist with a deep sense of stewardship for its revealed historical narrative.

The idea for this exhibition has been simmering for several years, although curatorial decisions, with such a clear subject and uniformly high quality of objects, were quite straightforward. It was decided not only to feature the paintings but also to include the artist's study models, research materials, working drawings, and sketches—all of which allow more participation by the viewer and illuminate the architectural knowledge of the artist as well.

Many artists experience a crisis of confidence and purpose and if L.F. Tantillo has, it is not evident in these works. Tantillo looks at how one defines history and questions: "Whose story is it?" He has a fervor and will to include the *other* voice, too often eliminated in past historical narratives, which were often based on political motives. He is unabashedly American and proud of it. He loves the region in which he works and infuses each piece with an integrity and sense of purpose found in the work of America's greatest painters. Whether he is depicting the heroic acts of daily life or the narrative themes of American history, his enthusiasm, deep sense of moral character, and love of narrative painting are robustly present.

In the work *Winter in the Valley of the Mohawk*, Tantillo uses his artistic acumen to beautifully convey his empathy for his subject. The cold and hungry hunters approach home, the longhouse, with the promise the beckoning fire holds and the expectation of the warmth and storytelling that is to come. It is a stunning work and reveals the artist's innermost soul and deep desire to stir the emotions and move the viewer.

Warren Roberts, a professor of history at the University at Albany, is the ideal essayist for the introduction to this exhibition catalog. He brings to the project not only his status as a renowned historian but his keen appreciation and knowledge of modern art. His essay enlightens and informs and places the artist's work in both an art and a historical context. We are deeply in his debt for his important contribution.

Other writings complement this publication and make

a significant contribution to the project as well. We sincerely thank Stefan Bielinski, Shirley W. Dunn, Charles T. Gehring, David R. Gould, Paul R. Huey, Philip Lord, Jr., Roger W. Mabie, Joseph F. Meany, and Wendell Tripp.

Ultimately all exhibitions are the result of the generosity of lenders. In this exhibition we were fortunate indeed to have two magnanimous lenders who are also the major sponsors of the exhibition and its publication: a very special thank-you to Richard Molyneux, president and chief executive officer of KeyBank, and Warren Greatbatch, president and chief executive officer of Wilson Greatbatch, Ltd. We are grateful indeed for their generous support.

We are indebted also to other special lenders and supporters of the exhibition and catalog, who gave their support in large measure: 1843 Central Avenue Associates, Patrick and Mary Ann Mahoney, David A. Wolfe, and the University at Albany Foundation.

Many, many people were helpful in the production of the exhibition. Zheng Hu, the museum's designer, applied his considerable talent and intelligence; Corinna Schaming, assistant to the director, and Joanne Lue, museum secretary, oversaw every detail of the exhibition with precision, accuracy, and foresight. Jeffrey Wright-Sedam, assistant to the designer, was tremendously effective, as were the other members of the student staff. Greg Petersen, a doctoral candidate at the University at Albany, researched and authored the excellent "Educator's Guidebook" for the exhibition.

Finally, my special thanks and appreciation to the artist L.F. Tantillo for all his collaborative efforts on behalf of the museum and the exhibition presentation. His personal involvement enabled negotiations with the lenders to proceed. In addition he granted me unlimited access to his studio and personal collection, from which the exhibition was curated. He has unfailingly given his cooperation during all phases of the exhibition production, which far exceeded early curatorial plans.

It is with great pleasure that we present "Visions of New York State: The Historical Paintings of L.F. Tantillo" to the museum's academic and regional audiences. As a museum within an academic institution we are proud of our transdiscipline offerings and pleased that this exhibition will be integrated into the many disciplines and programs at the University at Albany.

Marijo Dougherty, Director
*University Art Museum*

There are a number of reasons why I paint the history of upstate New York, beginning with the fact that this is my home. Our nation has a wonderful and rich heritage that is ingrained in us from our earliest years in school. However, by emphasizing the grandest events of our collective past we often lose sight of the role that local communities played in forming the country we have today. That approach to learning causes a kind of historical inferiority complex and leads us into believing that history happened somewhere other than where we live. I believe that local and regional history are important and that by understanding and appreciating our past at a grassroots level we can deal more effectively with the future of our communities. I would like the body of my work to contribute to that awareness.

The subjects I choose to paint are often obscure and unfamiliar. Arriving at a credible image requires a great deal of research. I've had the great fortune to meet and work with many of New York's most knowledgeable and devoted historians, and I see myself, in part, as a communicator of their efforts. The information they share with me not only answers specific project questions, but often becomes the inspiration for future work. I respect and admire their tenacity, professionalism, and boundless curiosity.

I have been painting and drawing all my life. It is an endlessly fascinating endeavor. For me it is a language with an infinite vocabulary. The process of applying brushfuls of color across the gessoed fibers of tightly woven linen is exhilarating and addictive. Over the years, I've learned to accept the pattern and pace of each individual painting. Challenge, fear, expectation, disappointment, progress, doubt, joy, and satisfaction accompany each work and never occur in any particular order. I never know exactly what the next session will bring. I'm convinced that there are as many different motives for painting as creative people to do them. My goal is to capture on canvas what I see in my imagination and communicate that image clearly to the viewer.

Detail painting takes time. For over fifteen years it has consumed most of my working hours. I've been fortunate to have the support of an appreciative and enthusiastic group of patrons. Together we have collaborated on much

of the work contained in this volume. In my experience, patrons can influence the creative process in a positive way and provide the incentive to move forward. I thank them for their help and encouragement.

In conclusion, I would like to thank the University Art Museum at the University at Albany for giving me the opportunity to share my "Visions of New York State," both at the gallery and in the form of this exhibition catalog. The task of assembling the literally hundreds of exhibit items and organizing them into a coherent presentation is monumental and deserves much appreciation.

It is my hope that you will find this work as interesting and enlightening to view as it was to create. Join me in celebrating our heritage.

L.F. Tantillo

# Visions of New York State

# History Painting, American Art, and L.F. Tantillo

**Warren Roberts**

The works of L.F. Tantillo presented in *Visions of New York State* have a historical dimension, a tradition of painting that has all but disappeared from American art during the past 150 years. A good place to begin the story of American history painting is with Benjamin West's trip to Italy in 1760. Born in 1738, West had studied briefly in Philadelphia, but the training was not adequate for the career he hoped to establish as an artist. As a student in Rome he absorbed the principles of Johann Winckelmann and Anton Raphael Mengs, the leading proponents of the neoclassical style. To achieve the elevated goals of neoclassicism, an aspiring artist had to master the human figure, which one did by copying antique sculptures or casts and the Old Masters and by drawing nude figures. Only after acquiring the requisite technical skills could the student artist receive instruction in painting. The venue for this program of study was an art academy, where students received formal training. Within academies there was a hierarchy of genres, history being the most prestigious category. Since the time of the

Renaissance artists had looked to antiquity for inspiration, so much so that they tended to live in its shadow, and it was to the classical past that academic artists went for the selection of high-minded and elevated history subjects. It was the category of history painting that drew Benjamin West into its orbit in Rome.

After three years of study in Rome, West settled in London, where he set up his own studio, which became a mecca for aspiring American artists who strove to approximate his success. And West's successes were spectacular. His early works in the history genre were conventional and formulaic paintings that in the usual manner portrayed subjects from the classical past. They were not particularly better or worse than the paintings of other neoclassical artists of his generation, but in 1770 West struck off in a new direction in his brilliantly innovative *The Death of General Wolfe*. By choosing a scene from modern history, West struck a responsive chord among contemporaries who, even as they admired antiquity, took pride in the achievements of their own age. A spirit of patriotism was welling up within the western world,

and the deeds of modern heroes could inspire admiration along with the greats of antiquity. Benjamin West, an American, tapped a contemporary reservoir of feeling when he portrayed the heroic death of an English general, and for this he was rewarded in 1772, when he was appointed history painter to the king of England. George III favored West with his personal patronage and friendship for forty years, and in 1792 West succeeded Sir Joshua Reynolds as the president of the Royal Academy of Arts.

John Singleton Copley (1738–1815), an exact contemporary of West (1738–1820), had already achieved a considerable reputation in his native Boston, primarily as a portraitist, when he traveled to London in 1774, where he settled permanently after traveling for a year on the continent. Following West's example he became a member of the Royal Academy in 1779, and, like West, he turned out history paintings representing modern events rather than subjects drawn from the classical past. Initially successful in these works, Copley's popularity faded and, after 1800, buyers no longer beat a path to his door. Another young American artist who strove to further his career by joining West in London was John Trumbull (1756–1843), son of Jonathan Trumbull, who was the governor of Connecticut during and after the Revolution. An active participant in the American War of Independence, Trumbull not only fought in the Revolution but illustrated some of its principal events. In 1780, with a letter of introduction from Benjamin Franklin, he sought out Benjamin West to study under him. After acquiring the grand manner essential to history painting, Trumbull turned out a series of large paintings that portrayed events from the recent past, such as *The Death of General Warren at the Battle of Bunker Hill, 17 June 1775* (1786). In effect, Trumbull adapted West's style of history painting, with its high rhetoric and moral seriousness, for American subjects. Having

Benjamin West, *The Death of General Wolfe* [1770]. Reproduced by permission of the National Gallery of Canada, Ottawa.

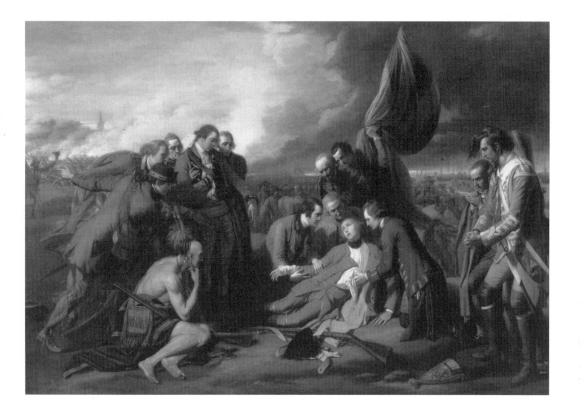

achieved success in England as a history painter, Trumbull returned to America and thereafter continued painting popular Revolutionary subjects, but with less success as they became hollow reworkings of his earlier paintings.

Neoclassical history painting in the grand European manner did not take hold in America. American artists who went to Europe to acquire that style and achieved notable successes there as history painters were unable to repeat those successes when they returned to their native land. The tradition of European history painting was closely tied to academies of art and to a system of state patronage that was essential to its vitality. In America there were no academies of this type and no formalized program of training to impart the technical skills and canons of style necessary for history painting to achieve its elevated ideals. Moreover, neoclassicism was a highly theoretical style that was essentially alien to the American democratic temper, as was history painting when it obeyed the tenets of that style. A whole generation of American artists who went to London to study under Benjamin West, including Washington Allston, Rembrandt Peale, Thomas Sully, Matthew Pratt, Samuel F.B. Morse, and Charles Willson Peale, as well as Copley and Trumbull, schooled themselves in a tradition that ended up as an artistic cul-de-sac.

This is not to say that history painting died out in America after 1800, when the generation of students trained under West was unable to transplant a European style into American soil. America was not receptive to elevated history paintings that adhered to the theoretical canons of European classicism, but the history impulse had not expired. On the contrary, the impulse was strong, but it could be a living force in American art only when it was assimilated by other styles. Precisely when West's students returned to America from England, landscape painting was becoming a force of unrivaled vitality in American art. Painters who turned to landscape painting accomplished what frustrated history painters had not been able to achieve; they created a serious and elevated style that struck a responsive American chord. Formally far removed from history painting, landscape painting became a conduit through which an abiding interest in things American passed. Already in the 1770s and 1780s West's students had turned to contemporary subjects when they portrayed events from the American Revolution. Americans understandably looked not to the past as much to the present, and they were drawn to the natural splendors of their own land and to the vast opportunities of an untamed wilderness. An artist who anticipated the Hudson River School was Washington Allston (1779–1843), yet another American who studied under West in the Royal Academy. It was not history painting that attracted Allston but the landscapes of Claude Lorrain and Frederick Jackson Turner, and when Allston returned to America he invested his landscape paintings with a sense of the timeless that he acquired from his

European models. At the same time, Allston painted real places—rivers, farms, country estates, and the towns that dotted the American countryside.

Thomas Cole (1801–48) was born in England, emigrated to America with his family in 1819 when they settled in Ohio, and took up residence in the town of Catskill, New York, after studying in England. In two grand series of paintings, *The Course of Empire* (1836) and *The Voyage of Life* (1840), Cole painted large panoramic tableaus that resembled landscapes compositionally but portrayed subjects that were historical. In these paintings Cole depicted the rise and fall of civilization and the eternal journey from life to death; in *The Garden of Eden* and *St. John in the Wilderness* he portrayed scenes from the biblical past; and in *Scene from "The Last of the Mohicans"* (1827) he combined landscape with a subject of particularly American relevance, the encounter between Europeans and American Indians. If landscape offered artists of the Hudson River School opportunities for poetic visions and visual exercises in the sublime, it was also a vehicle to portray real people within a geographical space that framed their lives, and whose travails and inventiveness was part of their historical destiny. Paintings of ships on the Hudson River served a poetic end, and they expressed the interplay between man and nature. As the nineteenth century progressed, paintings of sailing ships on the Hudson gave way to steamships, expressions of historical change. Also, the generation of landscape painters after Cole broadened their horizons. Frederic Edwin Church and others traveled to South America, but also, and more important, artists such as Albert Bierstadt went to the American West to portray its vast and untamed vistas.

The historical impulse after 1800 was by no means limited to landscape painting. Also, and more directly, it found expression in genre painting that became a major part of the American artistic scene during the 1830s. Artists who specialized in scenes of everyday life captured a sense of Jacksonian democracy and its energies and affirmations. George Caleb Bingham (1811–1879) was trained at the Pennsylvania Academy of Fine Arts, but he also studied books and prints and was in some measure self-educated. If Bingham's formal training is evident in paintings informed by a firm sense of geometrical order, so too is an abiding interest in the pursuits and strivings of contemporary Americans from the great Midwest. Within the large and impressive output of this superb artist there are scenes of life on the Missouri, political elections, American Indians, squatters trying to eke out an existence on the American plain, and the injustices that attended the struggle between the North and South in the American Civil War. Bingham had already painted some of his finest works when he traveled to Europe and spent a two-year period of study at Düsseldorf in 1856–58. A regional Rhenish town of 40,000, Düsseldorf claimed an art academy that espoused the

cause of history painting, and it was there that Emmanuel Leutze (1816–68) had studied before the arrival of Bingham. Born in Germany but raised in America, Leutze traveled to Düsseldorf in 1841, where he acquired the formal language of European history painting. Steeped in the high rhetoric of that style, Leutze returned to America and painted the colossal (12 x 21-foot) *Washington Crossing the Delaware* (1851), arguably the best known of all American history paintings. Bingham claimed to find a "simple and rational" art in Düsseldorf and vowed not to take up a new style that might alienate American audiences, but the fact is that he did acquire something of the European style of history painting in Germany, as seen in his own *Washington Crossing the Delaware* (1856–71), a painting that clearly indicates indebtedness to Leutze. Begun in 1856, just before departing for Düsseldorf, Bingham completed the work after he returned to America. He had painted figures on river rafts in earlier genre works, whose plain and straight-forward American simplicity is in striking contrast to the tendentiousness of *Washington Crossing the Delaware*. A comparison of Bingham's *Jolly Flatboatmen* (1846) with his later Leutze-inspired history painting suggests how right he was in trying to avoid the formulas of the Düsseldorf school. Having fallen into the very trap he wanted to avoid in *Washington Crossing the Delaware*, he did so again, in some measure, in *Order No. 11* (1865–70), another late Bingham painting that is weight-

ed down by the apparatus of European history painting.

Winslow Homer (1836–1910), an artist of the generation after Bingham, was trained as a lithographer and turned to painting fairly late, when he was depicting scenes of the Civil War for *Harper's Weekly*. His *Prisoners from the Front* (1866) expresses discomfort over a war that he had witnessed directly. It is noteworthy that Homer was not alone among American artists in turning away from a military struggle that created a lasting division within the nation and left a legacy of bitterness that has not yet been overcome. It is the photographs of Mathew Brady that offer the fullest and best record of the Civil War, not the paintings of American artists. To the extent that the Civil War affected the historical impulse in

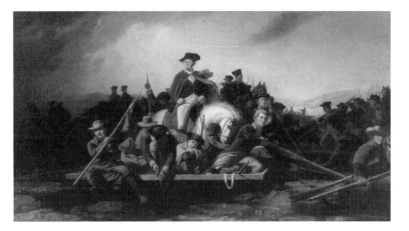

George Caleb Bingham, *Washington Crossing the Delaware* [1856–71]. Reproduced by permission of the Chrysler Museum, Norfolk, Virginia.

American art, it weakened rather than enlivened it. Homer traveled to Paris in 1867, the year after he completed *Prisoners from the Front*, where he was influenced by Edouard Manet and the emergent art of impressionism. When Homer returned to America he painted scenes that projected what poet Charles Baudelaire called the heroism of modern life. The dignity and quiet grandeur of Homer's *Inside the Bar, Tynemouth* (1883) is heroic, not in the same way as a European history painting, but rather in a contemporary American sense. Yet it does not tap into a vein of national or historical feeling in the same way as the genre paintings of Bingham and other artists of the previous generation. This is true also of the landscapes and genre paintings of Thomas Eakins (1844–1916) from the 1870s and 1880s, as well as the productions of James McNeill Whistler (1834–1903) and John Singer Sargent (1856–1925). History painting had by no means run its course in the decades after the Civil War, but it did not draw the leading artists into its orbit. Whereas history painting was all but detached from high art, there was continuing demand for murals in public buildings throughout the late nineteenth century and well into the twentieth century. A last gasp of this tradition was the proliferation of WPA paintings in public buildings across America; these paintings, commissioned by the federal Work Projects Administration between 1935 and 1943, either were historical in the narrative or biographical sense or tapped a vein of feeling for American life and tradition. There was also a continuing current of historical illustration, but for the most part high art turned away from history painting after the 1870s.

The 1913 Armory Show sowed the seeds of American modernism by introducing a generation of artists to the latest European avant-garde styles: cubism, fauvism, constructivism, and futurism. Max Weber's *Rush Hour, New York* (1915) expresses the dynamism of American life, but through the language of cubism. Morgan Russell turned away entirely from representational art in *Cosmic Synchrony* (1913–14), a painting that helped establish abstract art in America. A current of representational art that portrayed scenes of American life from Eastern urban cafes (Edward Hopper's *Nighthawks*, 1942) to the rural Midwest (Grant Wood's *Stone City, Iowa*, 1930) to the Far West (Thomas Hart Benton's *Arts of the West*, 1932) did pass through the first half of the twentieth century. A vivid sense of American life was captured by the Ashcan School and in a quite different way by Norman Rockwell. Although Rockwell stuck to his chosen path into the 1970s, the distinctively American art of the Ashcan School and artists under their influence ended in the 1940s. These artists, the members of an American school of painting that retained the language of representational art, went into eclipse after World War II. A new school of American artists, the New York School, took the lead after 1945, as New York became not only the center of

American art but actually displaced Paris as the dominant force in contemporary art. Abstract expressionism is at the farthest possible remove from history painting, and to the extent that American subjects are present in the art of the New York School, those subjects are something to be parodied or to pass through the ironic prism of the modernist artist's acerbic sophistication. But the art world does not stand still, and from the vantage point of the 1990s we can look back at the New York School with a historical perspective. We can also see countercurrents, such as the superrealism of Malcolm Morley, Gregory Gillespie, and Richard Estes. What we do not find in these artists, for all of the photographic detail in which their paintings are rendered, is a historical dimension. It is to another artist, L.F. Tantillo, that one can turn to find not only a historical dimension, but paintings whose very purpose is to portray scenes from the American past.

Leonard Francis Tantillo was born in Poughkeepsie in 1946 and grew up in New Paltz, New York. Except for a five-year-period of study at the Rhode Island School of Design, Tantillo has spent all of his life in upstate New York, whose indigenous peoples, history from the period of Dutch settlement to the present, and rivers, towns, and cities he has painted almost exclusively. It had not been his original intention to become an artist. Rather, his parents encouraged him to follow a more practical path to a career as an architect. After graduating from the Rhode Island School of Design in 1969, Tantillo returned to upstate New York to accept a position with an Albany architectural firm. Tantillo had never felt in his element in Rhode Island or in New England; he is drawn to the Hudson River Valley, its geography, its past, and its traditions, to the Dutch influence, to the sailing ships and steamships that have plied its waters, and to the towns that have developed on its banks.

As a profession, architecture was not what Tantillo expected. Too much of his time was given to factoring cost, too little to design; too much of his work was routine, too little gave scope to originality and creativity. Yet these frustrating early years spent working for architectural firms were not without their rewards, and in some measure they helped kindle interests that would surface later and point Tantillo in a new direction. He learned to appreciate historical architecture and the period styles and old buildings in which this part of New York is so rich. As a designer he could not use models of buildings but had to express his ideas in drawings, two-dimensionally. The constraint allowed him to develop techniques and renewed his interest in

L.F. Tantillo, architectural rendering [1982] (Einhorn Yaffee Prescott).

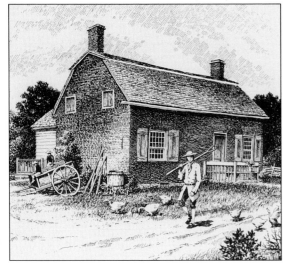

L.F. Tantillo, *The Defreest House* [1982] (Patricia Roberts).

drawing. In 1976 he set up his own business as an architectural illustrator and obtained his New York State architectural license. He received commissions from architects to prepare drawings for projects on which they were submitting bids, and the flow of work not only exceeded his expectations but came from leading national firms. Tantillo had now reached a level of success that enabled him to be selective when he accepted commissions, and those that he found unusually rewarding were restoration projects, for which he drew buildings as they would appear after being restored. He sometimes did these renderings in the style of the period in which they had been built, as if his own sense of the past dictated the style of his illustrations. Then came the moment of truth, what one might call Tantillo's epiphany. It took place in the summer of 1983, when he and his family were vacationing on Martha's Vineyard. In one of the art galleries they visited, he saw a painting of Baltimore Harbor, circa 1900. "I can do that," he said to himself and decided to prove that he could. It was the challenge for which he had been preparing all his life. His special focus, he decided, would be on historical subjects within the provenance of upstate New York. Tantillo returned home to devote himself passionately to work on *The City of Albany, New York,* a historical painting of

Albany, circa 1868. He did several sketches, began painting, and with painstaking attention to detail brought the large (40 x 60-inch) work to completion in 1985.

From the beginning of his career as a history painter, Tantillo strove to recreate scenes from the past so that others could see how everyday life actually looked. His work as an architectural illustrator had refined his skills in representing buildings, and his drawings for restoration projects had steeped him in the styles of period architecture. But *The City of Albany, New York* is not an architectural drawing. It is a painting, a work of art. Tantillo's undergraduate studies served him well as he made the transition from architectural illustrator to history painter, his new calling. All students at the Rhode Island School of Design took the same courses during their first year, including figure drawing and nature drawing. Students went on field trips to downtown areas, where they looked at bus stops, lunch counters, wherever people gathered. Tantillo was told to look at people's feet, to study their clothing and their faces, and to draw what he observed. The idea was to capture on a sketch pad what the eye saw—figures who stood or sat in different positions, clad in clothing of different types and textures. In his nature class Tantillo painted various objects—vases, tables, chairs, real things that caught light and cast shadows. Being able to draw the human figure convincingly and to convey a sense of physical objects on a sheet of paper required a high degree of discipline, and it required tech-

nique. Now, as a professional artist, Tantillo had to master a new medium of acrylic, and he worked with a new purpose, to create a work of art, but he was well grounded in the rendering of physical objects and he could depict the human figure naturally and with assurance. There were lessons to be learned and skills to be honed, but from the beginning Tantillo had the technique to carry off his first history painting with stunning certainty.

From the beginning his approach to history painting was his own. His goal was to recapture scenes from the past; he wanted to know as fully as possible how Albany looked around 1868, and he did extensive research to render it accurately. In subsequent works he would collaborate with consultants with specialized historical and archaeological expertise in the various periods he represented in his paintings. Out of those collaborations came history paintings that enable us to see physical spaces that are no longer as they once were. *Fort Orange, 1635* (1986) is one of Tantillo's most ambitious attempts to reconstruct the past, but his *Return of the Experiment* (1994) is hardly less so. Working from the De Witt Map in the New York State Museum, the 1770 Yates survey map, 1770 city records, Albany newspapers, papers of the sloop *Experiment*, various period publications and archaeological information, and from his own scale models of colonial Albany and of the sloop *Experiment*, Tantillo has created the only existing painting of the city's waterfront from this period (1787). The artist's *Steamboat Square*

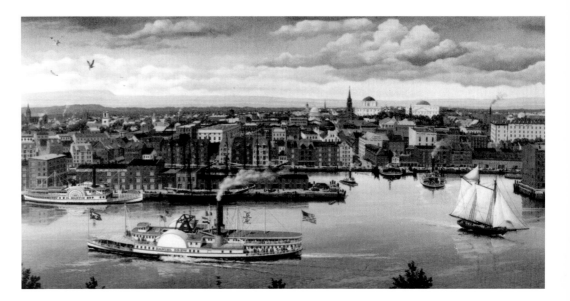

L.F. Tantillo, *The City of Albany, New York* [1985] (Michael B. Picotte).

(1990) shows the steamboat *Alida* as it approaches a wharf in the center of Albany in 1852. To compare this painting to *The Return of the Experiment* is to see in a wealth of detail how Albany changed between 1787 and 1852. *The City of Albany, New York* shows the city circa 1868, after the construction of a man-made harbor that receives passengers and cargo from ships that ply the Hudson River. Buildings are seen on both sides of the harbor that played such a vital role in the economic life of nineteenth-century Albany. In the background, some structures that still stand can be seen, such as the Cathedral of the Immaculate Conception, but others that mark the skyline, such as the old State Capitol building, have disappeared. Those familiar with present-day

Albany can compare the city they know to the one Tantillo has reconstructed in his painting. The harbor that is so prominent in *The City of Albany, New York* is completely gone, as is the row of buildings on old Quay Street. Tantillo's *Union Depot, 1879* (1992) shows the Union Depot, a Victorian building with a mansard roof built in 1872 and demolished in 1899. This and other history paintings are a superb and accurate record of the changing face of Albany from the earliest Fort Orange beginnings to the late nineteenth century. Through Tantillo's Albany paintings one has unique access to the history of the city. Painted with unswerving attention to physical detail, these works describe the various changes through which the capital of New York State has passed.

Tantillo has not been content merely to provide a visual record of historical change; as a history painter he wants to go beyond a narrative mode. He believes historians should not limit themselves to the outer shell of the past, to factual data, but should tap into and examine its interior life, that of social and human experience. He regards himself and his art as a catalyst that brings the past to life for his audience. "I am a storyteller," he says, and the stories he tells are important stories. The physical spaces within which we act out our lives are not as they once were—and seeing how people experienced those spaces in the past gives us a fuller sense of where we live and who we are. "We know bits and pieces of the past, but we don't know how they fit together. I try in my paintings to show how things fit together. My images make the past real to others—they can see the past and experience it." In a description of *The City of Albany, New York*, Tantillo provides the detail he visualizes as a history painter:

> The industrial revolution was underway and American port cities were bustling with activity. The capital district of New York State was no exception. With the end of the Civil War came a new vigor. The Hudson River was busier than ever. The Albany Basin was the upstate hub of marine commerce. Heavily laden schooners and steamboats transferred goods through the basin bound for the inland ports of the Great Lakes and the cities of western New York via the Erie Canal. Earth-toned masonry structures crowded every available foot of riverfront property, as vessels of steam and sail maneuvered in and out of port. The city of Albany was growing.

Through the eyes of the artist we get a glimpse of that golden age. We sense the texture of nineteenth-century urban life from the hard edges of the buildings and the flow of the river. The sharp detail allows our imaginations to take us through the streets and along the waterfront of a city and time long past.

As much as Tantillo admires artists of earlier genera-

tions who painted historical subjects, he is critical of inaccuracies in their works: buildings in the wrong style of architecture, clothing from the wrong period, and figures whose body language was the result of artistic convention, not historical realism. With the insight of a historian, Tantillo recognizes that his reconstructions of the past might not be accurate in every respect and that subsequent research might prove this or that detail incorrect. What is striking about his historical paintings is his pursuit of accuracy and the research, undertaken with the help of specialists, to get things right. This is far removed from an earlier tradition of American history painting that was derived from European models. The historical paintings of Benjamin West, John Trumbull, and Emmanuel Leutze portrayed epic scenes from the past in a grand and elevated manner that was far removed from the realities of American life. Coming to history painting in his very different way, Tantillo does not impose a derived style on his chosen subjects but strives through his own style to recapture the past as accurately as possible.

Not surprisingly, Tantillo admires the Hudson River School, although he has not emulated the artists of that school. An artist for whom he feels a particular affinity is Edward Lamson Henry (1841–1919), a New York State artist who painted historical scenes. Henry began a series of railway paintings in 1864 that he continued to work on for at least three decades. He also painted scenes from the Erie Canal and from the Hudson River, but he is not, properly speaking, a member of the Hudson River School. He was not a painter of landscapes so much as an artist who was drawn to the past and tried to reconstruct it in historical paintings. Henry's *First Railway Train on the Mohawk and Hudson Road* (1892–93) portrays the maiden run of the De Witt Clinton engine in September 1831. Henry strove in this painting to document the scene with utmost historical correctness; he was careful to include coaches from the period as well as to render the locomotive accurately. In his efforts to document the past, Henry collected period furniture and clothing, and in *The First Railway Train on the Mohawk and Hudson Road* he was at pains to show figures in proper attire for the time. Henry's agenda is strikingly similar to Tantillo's. Yet the two artists are far removed from one another stylistically; the latter admires Henry but is not in his debt as an artist. Tantillo also admires the seventeenth-century Dutch masters and twentieth-century artists such as N.C. Wyeth, Maxfield Parrish, and Norman Rockwell. But he does not imitate any of these painters. His style is his own, a vehicle that enables him to tell a story. The essential impulse behind his work is historical, and this impulse is personal and particular to his own vision.

Emotional response is one of the main components of Tantillo's art, arguably the most important. One of his objectives has been to develop a style capable of evoking feeling in the observer. As an architectural illustrator he had reached a point where he could see buildings as draw-

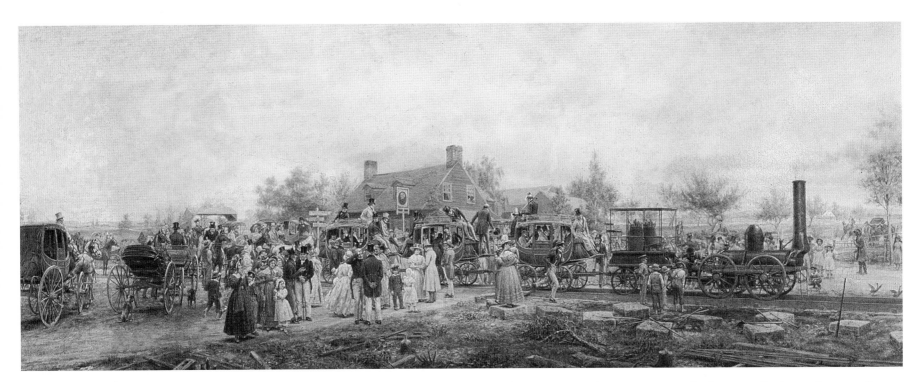

Edward Lamson Henry, *The First Railway Train on the Mohawk and Hudson Road* [1892–93]. Reproduced by permission of the Albany Institute of History and Art.

ings, but to imbue a painting with emotion, he discovered, was more complicated and required a different artistic perception. With time he has achieved a mastery of his medium, acrylic. In *The Old Erie Canal* (1987) the faint red glow of a summer afternoon in 1895 is reflected on the shallow water of the canal at Lock 33, St. Johnsville. The reflection of the sunset on the water, the men on the towpath, and the figures on the bridge who stare downward at the canal invest the painting, as Tantillo describes it, with "a romantic adventure through a beautiful wilderness." The reflective beauty of *The Old Erie Canal* is in

striking contrast to the bravura display and sense of occasion of *The New York, 1895*, which captures, in the words of the artist, a "magnificent moment" in time. Tantillo admits that he has always been fond of this painting, whose 300-foot-long steamship, built in 1887, offers a stunning spectacle: "We are at the river's edge in Coxsackie, New York. In the foreground, the freight warehouse and its workers are totally in shadow. The afternoon has been stormy. In one magnificent moment the sun breaks through the clouds, illuminating the pristine white steamboat that glides into our view. In that

brief instant, all that is required of us is to revel in the glory of nineteenth-century elegance."

Tantillo wanted to trigger feelings about the spectacle, but at the same time he intended the painting to convey social commentary. Even as one is dazzled by the sleek Hudson River dayliner with its three stacks at midship, one notices the workers, in shadow, on the right-hand side of the painting. Pilings protrude from the dark of the river, boxes pile on the dock, and workers hoist sacks from a wagon into a storage loft. Lined up on the deck of the ship that captures the brilliant light of a late afternoon are passengers enjoying the amenities of the *New York* and the fine cruise up the Hudson River. Two worlds coexist in this painting, one of light, splendor, and leisure, and, by contrast, one of shadow, ordinary objects, and men who perform manual labor.

One of the keys to understanding Len Tantillo as a person and an artist is a small painting, *The General Store, 1938,* which shows his father's small grocery store in New Paltz, New York, opened in 1938. Among the customers in Joe Tantillo's store were migrant farm workers, pickers with little money to spend. Yet in Tantillo's Market they were treated with the same courtesy as everyone else. There were no distinctions; anyone who walked into the store was a customer. This is not a theory of democracy but a real world of democracy, grounded in respect for other people regardless of their wealth or purchasing capacity. To hear Tantillo talk about his father and the

family store, and the values that invested it, is to grasp a down-to-earth realism that is an essential part of his art.

At the same time that Tantillo's art rests on a bedrock of realism, it contains what he calls a "spiritual quality." As he reflects on his work, he does not find that quality in his early paintings: at the beginning, he says, he was rendering objects. He believes that somewhere in the period from 1988 to 1992 he came to think differently and feel differently about the subjects he painted, and about his art. A more recent painting, *Winter in the Valley of the Mohawk* (1994), shows two Mohawk Indians returning from a hunting trip in the dead of winter, with a wild turkey they have caught, to a cluster of longhouses atop a hill overlooking the Mohawk Valley. The Mohawk with the turkey strapped to his back trudges heavily through the snow, his head down, unaware of an individual standing between the longhouses at the top of the hill he climbs. The woman announces the arrival of the two hunters to others who cannot be seen but are gathered around a fire in the background, whose warm glow expresses the reception the two men will receive. Speaking

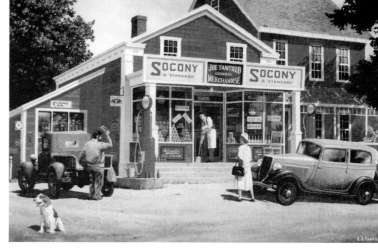

L.F. Tantillo, *The General Store, 1938* [1988] (Joseph G. Tantillo, Sr.).

of this painting, Tantillo comments on his optimism, for which he sometimes feels he should almost apologize. There is a common perception, he says, that a serious artist should suffer, and that art should express suffering. He does not believe that himself and does not want to project suffering in his paintings. In *Winter in the Valley of the Mohawk*, he could have shown the Native Americans freezing and in want, but it was his intention to portray success, reward for hard work, and anticipation of celebration. It is a painting that projects the very values that are bound up with Tantillo's family legacy, emphasizing the importance and rewards of hard work and perseverance. In this painting he has spiritualized those values.

Tantillo again shows Mohawk Indians in *The Trading House, 1615* (1995). The setting is Fort Nassau, the first European building in the state of New York. The fort is shrouded in mist on the top of a hill, and a Dutch ship is moored in the Hudson in the background. Two sailors who know nothing about America ("they might as well have been on the moon," says Tantillo) are building a crude structure of logs. Some members of the expedition will have to stay behind to hold the fort, and they hope it will not be either of them. The fort, located on Castle Island in Albany, was destroyed by a flood in 1617; before it could be rebuilt the head of the Dutch trading party, Hendrick Christiaensen, was killed in an Indian attack, along with most of his men. In Tantillo's painting, which portrays Dutch sailors and Mohawk Indians two years

before the fighting, Indians walk along a path between the white men, who observe them warily. The figures in the painting reveal their underlying uncertainty, at the center of Tantillo's conception of conveying the feelings that were an integral part of this historical scene. The effect comes through not with histrionics but by the carefully modulated responses of the two sets of figures. The Indians walk by, one carrying goods to be traded, one with a bow in his hand; neither looks at the Dutch sailors. For their part, the sailors look up from their work as the Indians pass by in silence. The figures are seen within a November landscape with rust-colored foliage on the side of a hill and the visible signs of European civilization in the background, Fort Nassau and the Dutch ship *Fortuyn*. Without the figures the painting would be a highly atmospheric and fine landscape; with the figures it achieves layers of feeling that issue directly from the historical scene Tantillo has chosen to portray.

In these two paintings, *Winter in the Valley of the Mohawk* and *The Trading House, 1615*, painted in 1994 and 1995, Tantillo gave figures a prominence they had not received in his earlier paintings. The figures are not an occasion for display, as they had been for earlier generations of history painters who rendered the human figure according to established conventions and drew from a tradition of elevated visual rhetoric. Tantillo's figures have been placed in the service of his artistic agenda, to recreate the past with utmost historical accuracy.

Figures are also prominent in Tantillo's most recent work, *Washington Street, Syracuse, N.Y.* (1996). In this superb painting Tantillo moves closer to the present than in his previous history paintings; this crowded urban scene has a modern ring that in the context of Tantillo's work is unique. The New York Central Railroad's Empire State Express that moves down Washington Street in the center of Syracuse is a stunning reminder of how the twentieth-century American city has changed. To show a train in the center of a downtown area is to remind us of a bygone age, one of trolley cars and modes of public transportation that have disappeared. If the train connects us to a period when urban life was organized differently, the automobiles in the painting are reference points of yet greater specificity. Parked on the right-hand side of Washington Street is a 1933 Franklin, which was manufactured in Syracuse. For the historically minded, a car is not just a car but a historical timepiece, and it is that sense that Tantillo integrates into *Washington Street, Syracuse, N.Y.* By giving the Franklin a prominent place in the painting he connects it to the city where it was manufactured, and he reminds us of an age in which there was far greater diversity in the production of cars than is now the case. Details such as this give historical specificity to the painting and, at the same time, evoke feelings that take us inside the life of this city in this period. The emotional response that the painting evokes is integral to the way Tantillo approached it. To capture on canvas a real sense

of 1933 Syracuse, he not only gave prominence to a train that was taken out of service three years later, in 1936, but he showed trolley lines, reminders of a bygone system of urban transportation. Further reminders of the past are figures attired in the clothing of the time, ornamental street lights, and the shops, now replaced by others, that line both sides of Washington Street. The shops are identified by signs that stir feelings of nostalgia; one of the signs is lit by bulbs, some of which have burnt out. In a wealth of carefully applied detail Tantillo recaptures not only the physical face of 1933 Syracuse but also a sense of how it felt to be there. Paint is the medium he uses to narrate the past and create atmosphere and feeling. It is the way in which Tantillo integrates these components into his history paintings that makes them works of art.

In the winter of 1995–96, an exhibit of Maxfield Parrish's work at the Norman Rockwell Museum in Stockbridge, Massachusetts, drew rave reviews and attracted large and enthusiastic audiences; one of Parrish's paintings sold for upwards of $5 million, a price that would have seemed unimaginable twenty years ago. The price of that painting and the success of the Parrish show are indicators of how American taste is changing at the end of the twentieth century. As we head toward the unforeseeable future of the next century, we seem to be returning to what in retrospect appears to be the greater certainties of the early twentieth century. In some measure we want to connect with our past. Also, there is

renewed appreciation of the mastery of technique that Parrish commanded and the use to which he put it. The separation between the virtuosic and sometimes sensual tableaus of Parrish and the formal constructions or psychic anguish of modernist high art could hardly be more complete. If contemporary currents of taste are not moving away from abstract expressionism, they do seem to be running with the representational art of Parrish and other artists who painted the contemporary American scene in the first half of this century. A recent exhibit at the National Museum of American Art in Washington, D.C., on the Ashcan School, like the Parrish show, drew large audiences. The artists of this school chronicled the rawness of American urban life in the early decades of the twentieth century, and artists such as Edward Hopper and Reginald Marsh, who came under their influence, continued to maintain a chronicle of American life through the 1940s. This too is of interest to today's art public; it too resonates with contemporary audiences.

The Autumn 1996 exhibit, "Visions of New York State: The Historical Paintings of L.F. Tantillo," at the University Art Museum at the University at Albany showcases an artist of great technical ability whose language is representational and whose paintings portray scenes of American life. His art belongs to the tradition of American history painting, even as it stands apart from that tradition. Tantillo does not portray historical events, battles, or patriotic events of whatever type. Like Edward Lamson Henry, he portrays scenes from the past, and he does so with unswerving attention to historical detail. He strives not only to get the details of his historical paintings right but to capture a sense of the past. He thinks of himself as a storyteller, placing his narrative within a historical context. What his ultimate place will be as a history painter, time will tell. His style has undergone change in recent years, and there are indications that his art might take new directions. Were Tantillo's paintings merely accurate images of the past they would be useful, as are historical illustrations, but they go beyond merely recording scenes of the past. He is an artist with a feeling for the past, and with superb technique he is able not only to capture the external dimension of the past, how it looked, but to draw audiences into its internal and spiritual life. This earns him a particular place in the tradition of American history painting.

*Warren Roberts is Distinguished Teaching Professor in the Department of History at the University at Albany of the State University of New York. He is the author of* Morality and Social Class in Eighteenth-Century French Literature and Painting *(1974);* Jane Austen and the French Revolution *(1979); and* Jacques-Louis David, Revolutionary Artist: Art, Politics, and the French Revolution *(1989).*

# The River Indians Meet the Dutch

## Shirley W. Dunn

Figures bring life to the rolling ships and reconstructed communities in L.F. Tantillo's paintings. In his earliest scenes, showing Fort Nassau and Fort Orange, Native Americans stride into view. They belonged to the land the Dutch had come to visit.

When the Dutch arrived, the land was fully occupied, and Indian populations were large. Friendly Mohicans were the dominant native group on the upper Hudson River. South of them were other communities, all river-oriented and speaking Algonquian languages. Later, these Indians were termed the River Indians, although some held large territories inland. Probably the largest area was controlled by the Mohicans, who laid claim to land from the mid-Hudson to the tip of Lake Champlain, and from the Housatonic River to a point west of today's Schenectady.

The Mohicans were astonished to see a strange ship sailing into view in 1609. They had never met Europeans before. In the role of friendly hosts, they welcomed Henry Hudson, the first European explorer on the river. The encounter was so overwhelming that Mohican historians kept the memory in their tribal lore for 250 years.

Early European visitors found the indigenous population in the valley living comfortable, even prosperous, lives. The Mohicans, for example, had great stores of beans and corn drying for the future, and, moreover, they were skilled at processing pumpkins, meat, fish, and berries for the winter season. Communal groups resided in comfortable loaf-shaped houses among the trees, using wooden, bark, and earthen vessels. Furs and hides provided clothing. Choice family fields were located near streams and ponds; the fields periodically were burned or returned to their natural state, to restore fertility.

The Native Americans hunted game in cooperative groups and alone, and they turned to the rivers and streams with nets and weirs for spring fish runs. In season, the Indian families feasted on passenger pigeons, ducks, swans, and geese. Young men made long trips in winter

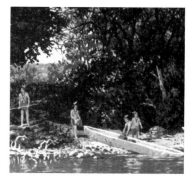

L.F. Tantillo, *Mohican Dugout Canoe* [1989] (Christopher L. Anderson).

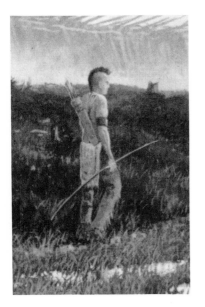

L.F. Tantillo, detail, *The Trading House, 1615* [1995] (David A. Wolfe).

for uncommon game such as moose. Knowing the environment intimately, the Indians manipulated the land to their advantage.

Their social and political traditions and regulations were fully formulated and served to guide Indian behavior with the strength of laws. The major sachem had advisors and was instructed to work for the good of his people as well as to provide hospitality. A council assisted him, and women and men provided supplies to help him meet his obligations. Lesser sachems served in the villages. Among the Mohicans, the opportunity to fill tribal offices was inherited through the women, but the best person among those eligible was chosen by consensus. Often land was controlled by women, who conferred with family members before decisions to move were made. Frequent communications among the villages dotting the territory assured united action when problems arose.

Families were small and children were cherished. Some Europeans accused the Indians of being overly fond of their children and very indulgent, never disciplining them. However, community pressure, family lectures, and strong traditions induced young people to conform. Storytelling transferred beliefs and legends. Divisions of labor between men and women were clear and apparently satisfactory to both genders.

The Mohicans and neighboring Indian groups main-

tained friendly associations and had wide-ranging mutual defense pacts. By tradition, the Mohicans had long ago separated themselves from the Lenape, to whom they gave the title of Grandfather. From the Mohicans, groups to the east had split off and evolved into nations. These ancient relationships made for unity and cooperation among neighboring groups. There were exceptions: to the west were the Mohawks, the easternmost tribe of the Iroquois alliance, with different customs and speaking a different tongue.

Previous to the Dutch arrival, the Mohawks had not been allowed in Mohican territory, according to Mohican accounts. Yet, within a few years of the arrival of the Europeans, the Mohawks were regular visitors to the Dutch traders. Their presence indicated a great change in the regulation of Indian society. This alteration was arranged by the Dutch traders, supposed friends of the Mohicans. Yielding to the Dutch persuasion, the Mohicans agreed to the building of a small Dutch fort on an island in the Hudson River, within their territory. The fort, called Nassau, was to be a center for trade in furs. To reach it, other Indians were permitted to cross Mohican land.

Some unwelcome Indian nations took advantage of the opportunity to traverse forbidden River Indian territories. Soon intergroup relations became volatile, as old

animosities were aggravated by close contact. Within a decade after the erection of the first Dutch fort, the Mohicans fought an unfortunate war with the Mohawks, after which the Mohawks confiscated some Mohican land and demanded tribute. Following long years of friction between the two groups, the Mohicans joined with New England Indians in an uprising against the Mohawks in the 1660s. Not until a century later did the Mohicans and the Mohawks resolve their conflicts over former Mohican land.

Len Tantillo's painting of the small fort named Nassau, on Castle Island, where now the Port of Albany stands, has caught the temporary nature of that first Dutch fort, and its minimal impact on the natural world. Its unseen impact on the Indian world was far greater. Soon the little establishment was gone, a victim of the floods common to the river. It was not rebuilt because the Dutch at home were quarreling over the privilege of trade with the natives in the Hudson Valley.

Several years later, in a new location on the mainland, a second fort—Fort Orange—was established. An early view of Fort Orange also has been painted by Tantillo, after careful research in Dutch accounts. His view succinctly dramatizes the impact of the Dutch world on the River Indians. Guns, European-style dwellings, an ocean-going ship, fur trading, pigs and cattle, Dutch goods

(including barrels of beer and rum), and European men, women, and children fill the painting. With them came the diseases from another world. The trends of the century to come were all there.

Even after the erection of Fort Orange, the expansion of the Dutch around the fort might have been halted if the Mohicans had not agreed to share their land. Beginning in 1630, they were persuaded to sell farm parcels near Fort Orange to the Colony of Rensselaerswyck. Although Indian landholding traditions were different from those of the Dutch, the Indians soon realized that the Dutch kept any land they acquired. However, Hudson Valley native populations continued to sell land, even when the truth of Dutch permanence was clear. Why not? Land was valuable. Indian needs were compelling. The old, prosperous life was gone. The formerly large and strong native populations had been vastly reduced by war and disease within a few decades. Pressures that induced the Native Americans to sell land included feelings of friendship for Dutch individuals, need for Dutch products, diminishing beaver resources, debts to traders, and Indian rivalry and warfare. Deceit and seduction with alcohol by Dutch traders entered the equation.

How much the River Indians, especially those who lived near the settlement that eventually became Albany, helped the Dutch colony! In the summers before Fort

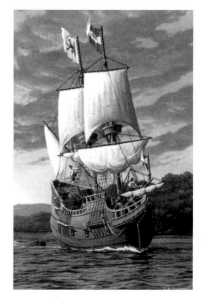

L.F. Tantillo, *Daybreak on Hudson's River* [1986] (artist's collection).

Nassau was built, the natives first took the earliest Dutch traders under protection to shelter them from tribes to the west. Years later, they helped the Dutch settlers during the Esopus Wars, when Mohican and Wappinger leaders were important mediators between Pieter Stuyvesant's forces and the hapless Waranawankongs (Esopus Indians); as friends of the Albany Dutch, the Mohican chiefs at Catskill kept those Esopus outbreaks from spreading to the farms of Rensselaerswyck and from enveloping Fort Orange and the village around it. Finally, at the close of the seventeenth century, when raids from Canada were a threat to the city of Albany, the local Indians helped again. Mohicans from below Albany and New England natives who were settled at Schaghticoke buffered the small, vulnerable city and repelled French and Indian attackers.

Today, the River Indians are not as well known as the Iroquois. However, for an important century, the Mohicans and most neighboring Indian populations of the upper Hudson Valley were friends and companions to the Europeans who came to their land.

*Shirley W. Dunn is the author of* The Mohicans and Their Land, 1609–1730 *(1994) and co-author of* Dutch Architecture near Albany: The Polgreen Photographs *(1996).*

# Dorp Beverwijck: A Dutch Village on the Hudson

## Charles T. Gehring

[The following descriptive tour begins at what was once the edge of the Pine Bush at the intersection of Eagle and State streets in present-day Albany, capital of the Empire State. Original Dutch spellings have been preserved throughout.]

The year is 1658. We are about to make a walking tour of a Dutch village on the upper Hudson. As we emerge from the pine forest we can see the Hudson River in the distance. The path we are following winds down a steep hill to a village below. The street at the bottom leads straight to the river. It is exceptionally broad, because roadways have developed on either side of a stream whose source is a natural spring on the hill. The stream is called the second kill. As we continue to walk toward the river we come to another roadway, which crosses our wide street. In the middle of the intersection is a church that can also serve as an emergency shelter. Turning left, we would soon cross the Vossen Kill, also called the third kill. Just outside the northern limits of the village is the brickyard belonging to a private estate. Instead we turn right

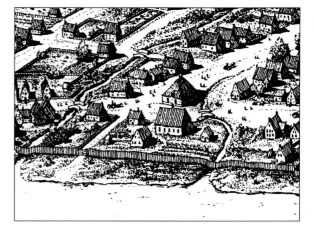

L.F. Tantillo, detail, *Albany, N.Y., 1686* [1985] (Stefan Bielinski).

and cross the first kill, also called the Rutten Kill and Fuyck Kill. Another roadway following the riverbank converges with our street at a fort in the distance. Approximately 120 houses line the streets. The village is called Beverwijck, the private estate Rensselaerswijck, and the fortification, Fort Orange. From the ramparts of the fort, the converging streets give the appearance of a conical-shaped fishing net called in Dutch a *fuyck*—a name by which oldtimers would nostalgically call the village long after the English had arrived.

The village is reached by water from the south—it is 150 miles from Manhattan. It is surrounded by potential enemies: Iroquois Indians to the west, French to the north,

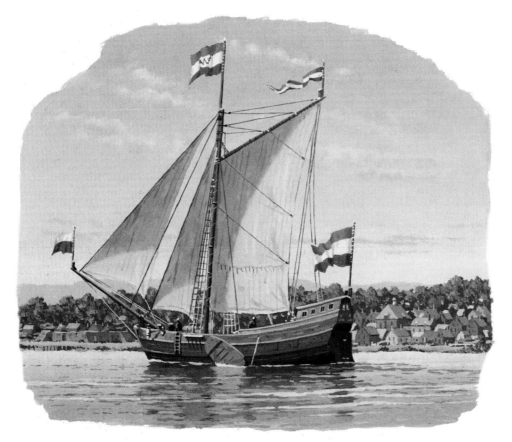

L.F. Tantillo, *De Eendracht* [1989]
(Cheryl and Charles Fangman).

evident that furs could be funneled out of the interior by the Mohawks and their allies along a route that led from the west down the Mohawk Valley to the Hudson Valley; the Cohoes Falls near the mouth of the Mohawk River forced traders on an overland route to the south, which met the Hudson River on the plain where the Dutch West India Company established Fort Orange in 1624. This Hudson-Mohawk corridor to the interior of the continent became the only access south of the St. Lawrence River for European trading interests. Consequently, Fort Orange developed into one of the most important trading posts in New Netherland. Its success was essential to the growth and development of the Dutch colony.

Everything we encounter in Beverwijck reminds us of a Dutch village. The architecture is distinctly Dutch: long narrow houses with the gables facing the street, pantile roofs, brick facing on the gable ends, wrought iron wall anchors configured to record the year of construction, stoops before the front door bordered by benches where the family can observe the passing scene or socialize with friends and neighbors. We hear the Dutch language spoken everywhere. However, several sights remind us that we are in the New World and not in the Netherlands: the ranges of mountains in the distance, the Adirondacks to the north, the Berkshires to the east, and the Helderberg

and English to the east. Between Beverwijck and its connection with the rest of New Netherland are numerous Indian tribes, called River Indians by the Dutch.

Ever since Henry Hudson's 1609 explorations in the *Half Moon*, Dutch merchants were attracted to this area by the potential profits of the fur trade. It soon became

escarpment to the south. On a clear day we can see the Catskills. These mountain views are unfamiliar within the United Provinces. The street that runs up the steep hill leads into a seemingly endless forest. On this forest path travel large numbers of Native Americans, bearing furs to trade in the village or passing through on expeditions to visit neighboring tribes—a scene that would also be unfamiliar to anyone from the Netherlands. Otherwise a Dutch visitor would feel perfectly at home in Beverwijck.

As we walk around the village streets, our senses are bombarded with the sights, smells, and sounds of an active and vibrant community. Carpenters are busy repairing old houses and building new ones. Masons are repairing chimneys and facing houses with brick produced in the patroon's brickyard on the north edge of Beverwijck. Blacksmiths are pounding out ironwork for the new house constructions and repairing tools for the agricultural community, especially the chains, clasps, hasps, clevises, and coulters necessary for the functioning of a good Dutch plow. Coopers are making containers large and small, including barrels for the several breweries in the village. Wheelwrights are making new wheels and repairing old ones for the ingenious Dutch wagons, which are seen everywhere hauling lumber and carrying grain and barrels of beer; on Sundays they are converted to vehicles suitable for carrying the family to church. The

sound of a horn signals that one of the numerous bakers has fresh bread to sell. Shoemakers are busy tapping soles, repairing old boots and making new ones. The many taverns are filled with people drinking the beer brought in from the breweries, exchanging news, and playing games. Animals are running loose everywhere—goats, hogs, and dogs. Vegetable gardens are tightly fenced in to keep four-legged intruders out. Milk cows are kept by most households in stalls at the back of the houses. Dairy products are an important component of the community's diet. At dawn a cowherd signals by horn for the assembly of the cows at the main intersection in front of the blockhouse church. The cows are then marched down the street across the Rutten Kill bridge, past the two-storied brick poorhouse, which borders the stream, along a street with gardens on the east side running down to the river bank. On the west side are houses containing taverns, gunstock makers, wheelwrights, and other trades and a newly constructed brick building where the village government, a board of magistrates, meets every Tuesday in ordinary session. The herd is finally released in the common pasture west of the fort, where they spend the day under the cowherd's watchful eye. North and south of the village are brick and pantile yards producing building materials for local consumption, and even for export as far away as the Delaware Valley. Water from the many kills supplies the

L.F. Tantillo, detail, *The Trading House, 1615* [1995] (David A. Wolfe).

power to operate numerous mills, which grind the grain for the breweries and baker's ovens and cut lumber for the construction of new houses.

The surrounding area is populated by farmers working land leased by the patroonship of Rensselaerswijck. They bring in grain for the bakers and brewers and agricultural produce for sale among the general population in the village. Their agricultural needs keep the wheelwrights, coopers, and blacksmiths very busy. Many farmers end up in the taverns to exchange words with other farmers about the weather and prospects for a good growing season. Several schoolmasters are kept busy instructing children and adults how to read and write, especially as a means to increase their devotion to the Reformed religion. The village dominie once proclaimed that he had three to four hundred people in church on Sundays and that it could be six hundred if all attended. A petition to call a Lutheran minister stated that there were seventy to eighty families of that faith in the area, mostly Germans and Scandinavians, an indication of the multi-ethnic composition of the population. Although native Dutch make up about 75 percent of the community, there are people from all over Europe, including Germans and central Europeans displaced by the Thirty Years' War, French fleeing religious persecution, and Africans brought over in the slave trade. All would learn to speak Dutch in order to gain access to the legal system and the commercial and religious communities. When the English took control in 1664 Beverwijck was renamed Albany but continued its role as a major trading center connecting Manhattan with the interior of North America. Although officially chartered as an English city in 1686, Albany retained its Dutch character. The Dutch language and customs—so firmly rooted in the community of Beverwijck—survived well into the nineteenth century. Its strategic location eventually turned the bustling Dutch village of Beverwijck into the capital of the Empire State.

*Charles T. Gehring is the director and translator of the New Netherland Project, New York State Library, Albany.*

# From Outpost to Entrepôt:
## The Birth of Urban Albany, 1686–1776

### Stefan Bielinski

At its chartering as a city in 1686, Albany was an urban village whose wooden stockade enclosed about 150 buildings that were homes and workplaces for its five hundred people. Most of those early Albanians were the children of the founders of the community who, forty years earlier, had come together to ship out animal furs bartered from Native American hunters drawn to Albany by a variety of interesting and inexpensive trade goods. Albany's original settlers were a diverse lot recruited by the Dutch West India Company from across Europe—with the Germans, Scandinavians, Continental lowlanders, and emigrants from the British Isles almost equal in number to actual natives of the Netherlands. By the 1650s, many of them had found partners in Beverwyck—the community's Dutch name— and were raising families.

Albany's native sons and daughters too had followed the fur trade. But now they were becoming collectors, processors, and shippers of farm and forest products and importers of supplies for a growing regional settler population. This commercial group had controlled the community's economy since its founding and had learned to manipulate the English provincial government for special privileges and for wilderness land. Albany's artisans and craftsmen, who formerly hammered, honed, and hemmed fur-trading items in their home workshops, now looked to supply hinterland farmers with processed and crafted products. Business, commerce, production, and a growing service economy based on river and overland transportation and on food, lodging, processing, and repair services all came together to make Albany a regional center recognized by royal governor Thomas Dongan with a municipal charter in 1686.

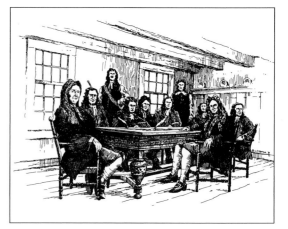

L.F. Tantillo, *Signing the Dongan Charter* [1986] (artist's collection).

With its court, city and county registry, regional market, fort, and churches, Albany had emerged as the administrative center of the huge Albany County established in 1683. By that time, the city of Albany was secure as New York's second center, and its people were cementing social and economic ties regionally and to Manhattan that only began with kinship.

While Albany County became the largest county in the colony, over the next hundred years, the city of Albany grew more slowly—despite a healthy natural increase of eight to ten births in a typical city household. By 1700, Albany had reached its capacity to absorb its native sons in traditional community-based activities. Most of them would find their destinies beyond the stockade. Rip Van Dam, Jacob Wendell, Philip Livingston, and others distinguished themselves in other settings. Some Albany natives became tenants of the Van Rensselaers or other regional landlords. Others farmed city land at Schaghticoke or relocated to new market communities such as Schenectady, Kinderhook, and Catskill or to a larger agricultural coun-

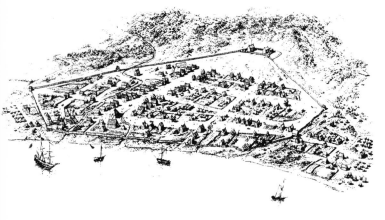

L.F. Tantillo, *Albany, N.Y., 1686* [1985] (Stefan Bielinski).

tryside beyond Rensselaerswyck. And still others dissolved into the obscurity of the American wilderness. Their places on city streets were taken by a small but steady stream of young men whose new skills and talents made them desirable partners for the daughters of New Netherland. The newer Albany people included some emigrants of New Netherland ancestry from downriver, such as the Cuylers and the Ten Eycks, who struggled to wrest benefits from a fading fur trade; individual opportunists such as Robert Livingston, whose outstanding talents made him an instant success; English and Irish garrison soldiers—the Barrets, Hiltons, Radcliffs, and Yateses—who became colonial Albany's largest immigrant group; Scottish traders and tradesmen named Glen, Henry, and Sanders; French Marselises, Pruyns, and De Garmos; German Abels, Hogstrassers, and Rubys; and Spanish Van Zandts. African slaves were brought in by city merchants. They raised their own families within Albany households, emerged from slavery during the era of the American Revolution, and accounted for between 10 and 20 percent of Albany's population throughout the eighteenth century. These diverse peoples came together in Albany homes to further enhance the social mosaic.

During the first half of the eighteenth century, Albany began to evolve from outpost to entrepôt. The business community followed an international market away from

the fur trade—instead establishing trade relationships with a growing number of regional farmers and husbandmen. Prosperous city merchants brought a volume of varied commodities to Albany, which they prepared and marketed with the support of extensive networks in the city's production and service economies. Traditional tradesmen and craftsmen turned out wood, metal, cloth, and animal products for city, countryside, and military use, as well as for Native American markets. During this time, Albany's makers and fixers resided in virtually every city family and became the largest part of the community economy. But they were beginning to be rivaled by those involved in service activities represented by a large Albany fleet of sloops and other riverboats, a growing number of inns and taverns, and the rise of tanning pits, asheries, and mill sites within sight of the core city.

During a three-decade respite from frontier warfare (1713–44), the Hudson-Mohawk region attracted new settlers, most of whom stopped only briefly at Albany to change transport and obtain supplies. During this time, the city of Albany spread out along the river as its population doubled to over two thousand by 1750. Now in their third and fourth generations in America, the New Netherland Dutch remained an overwhelming majority, although the number of New Netherland family names on city rolls fell from eighty to fifty during that time. New

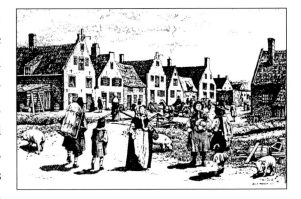

L.F. Tantillo, *Court Street* [1985] (Stefan Bielinski).

brick buildings filled in along State, Market, Court, and Pearl streets, while smaller frame dwellings of tradesmen and transporters began to ring the central commercial core. Beyond that were stables, sheds, shops, and storehouses. Albany had become the loading point for lumber, grain, and other exportable goods as well as the processing and repair center for an emerging region. New public buildings included a three-story city hall, courthouse, and jail, a massive Reformed Church located in the middle of the main intersection, and an Anglican (Episcopal) church. An enlarged stone fort and the development of another sixteen blocks within an expanded stockade further signified that Albany was no longer just a fortified village.

With the New York frontier a major arena of action, the Great War for Empire (1754–63) changed Albany forever. Frontier refugees, provincial troops, British soldiers, and an army of civilian newcomers seeking to serve them inundated the city during the 1750's, bursting traditional boundaries, setting new standards for opportunism, and placing great strain on a community economy that had been only better than self-sustaining in the past. The British built barracks, a large hospital, and many supporting structures and pushed general settle-

L.F. Tantillo, detail, *The Return of the Experiment* [1994] (KeyBank).

ment into areas that had been avoided previously as too hilly or too wet. Except for officers, few Albany men served in provincial armies. Instead they were put to work transporting soldiers and supplies, procuring and preparing food and fodder, and making and fixing shoes, wagons, and kettles. The war had stimulated Albany's service and production economies but also exposed a once-closed commercial environment to external competition, embodied by Scottish traders and by newcomers from New York, New England, and the other colonies. Albany's traditional merchants struggled in a post-war economy where success was based on access to imported items and external sources of credit.

The end of the war, a wave of European immigration, and the flooding of America with European products brought thousands of new people to and through Albany and drove home a number of lessons learned from first-hand experiences with the British and their policies. Finding their handcrafted items no longer competitive with imported products, Albany artisans were driven into repair work and to other services and found themselves less able to place their sons in traditional trades than in the past. Barred from manufacturing by imperial restrictions, would-be craftsmen either left the city or embraced the shipping, lodging, and processing activities of Albany's growing service economy. At the same time,

local ambitions for land patents, contracts, and appointment, frequently attainable in the past, were increasingly diverted to newcomers and others in the region who were more closely identified with the royal government and British policies. And finally, Albany people had suffered harsh treatment at the hands of the British army during the war, leaving many of these third- and fourth-generation Americans to wonder who would protect them from the British once the French and Indians had been defeated.

Between 1763 and 1775, colonial Albany underwent a final transformation. Its fortified character dissolved with the dismantling of the stockade in favor of a sprawling, again-expanded settlement. The closing of the fort and disposal of most of the military buildings ended a century of reliance on a military presence, in favor of an even more self-serving and still-evolving way of life that included many more important newcomers than at any time since the community's founding. Beginning in 1765, the city fathers underwrote construction of large docks and the development of the waterfront—thus creating landing and loading facilities that solidified Albany's role as the major inland port. An Albany fleet of sloops and lesser watercraft emerged to dominate the regional carrying trade but also reached beyond the Hudson Valley, sailing to the other colonies and to the Caribbean. The first roads radiating from city streets connected

Albany to Schenectady and to the agrarian hinterland and blurred the city/countryside distinction so pronounced in the past. The outer bounds of the city now were defined by Schuyler Mansion, Whitehall, the "patroon's" manor house, and other new country homes of Albany's leading families and influential newcomers. Watervliet, a new settlement area north of today's Clinton Avenue, was filling fast with newcomers whose daily toil helped fuel Albany's economy. These immigrant and migrant tenants of the Van Rensselaers spread out along the river and outnumbered the official residents of the city.

New, larger buildings began to appear on the main streets, and the advertisements of new State, Court, and Market street import merchants stood out on the pages of the *Albany Gazette*, the city's first newspaper founded in 1771. Hudson, Green, Barrack, Chapel, and Water streets, intersecting the main thoroughfares, were peopled by secondary businessmen, craftsmen and tradesmen, innkeepers, and transporters, and by a growing working class—who all represented both old Albany families and recent arrivals. These people were served by new Presbyterian and Lutheran churches, a new city market house, and a municipal government forced to meet new responsibilities occasioned by increased and more intensive settlement.

By the eve of the American Revolution, densely inhabited and ethnically diverse Albany had evolved into an acknowledged urban center. Greater Albany's six thousand residents fed a diversified community economy that served its people, an agricultural hinterland, an immense northern frontier, and a foreign market as well. Intense social and cultural changes over the past decade had created many new paradigms. Most city people struggled with these and were left feeling slighted and frustrated by their plight within the British empire. In the imperial scheme of things, cities were nerve centers and were located in England. The British would have preferred the colonies to have only market towns. But like a dozen other American urban centers, Albany was a city in every sense of the word. Underlying these realizations was the fact that most Albany people were not of English origin and felt no inherent connection to a British empire. Those who did became increasingly alienated from an Albany majority who, between 1774 and 1776, would come to understand that their destiny was no longer tied to the British.

*Stefan Bielinski is the director of the Colonial Albany Social History Project, New York State Museum, Albany.*

# Transportation and Transformation: New York State, 1790–1930

## Wendell Tripp

In 1790 the state of New York was poised for great adventure. The Revolution had been won; the new Constitution had transformed thirteen independent and squabbling states into a united nation; the once-powerful Iroquois confederation, divided and decimated by the Revolutionary War, was vulnerable to any treaty or purchase that the European Americans and their lawyers might impose as they looked with acquisitive eyes upon the green and fertile lands of central and western New York.

But the state in 1790, while dynamic and ambitious, was but a shadow of its future self. It was one of the smallest states in terms of population. European American settlement extended in a narrow corridor north along the Hudson River and west along the Mohawk River; New York City was a small urban cluster at the southern tip of Manhattan Island; Long Island was relatively isolated and sparsely settled. Travel on land was by horse or by foot and on water by sail or by oar. Men and women, when they wrote at all, used quill pens; books and newspapers were created of hand-set type and muscle-powered presses. The chores of field and workplace and of the home were done by hand with simple tools. Time was marked by the rise and setting of the sun. The arts were for the few, not the many.

Daily life, in short, was not much different than it had been a hundred years earlier. But before another hundred years had passed, New Yorkers would be propelled by steam, wear factory-made clothes, mark their days with clocks, write with fountain pens and even typewriters, and propel their words by telegraph and then by telephone. In another three decades they would be driving automobiles, watching movies, listening to radio, living in skyscrapers, flying through the air, and anticipating even greater miracles to come. In the process they would

explore or occupy every nook and cranny of a vast region that in 1790 held, all told, fewer than 400,000 souls.

At the beginning, New York had certain natural advantages, the chief of which was topographical: the valleys of the Hudson and Mohawk rivers and the plains and plateaus of western New York form the only passage through the Appalachian Mountains north of the Cumberland Gap. This axis, with the Great Lakes at one end and a magnificent natural harbor at the other, was a route of commerce, especially in an age when travel by water was supreme, but it was also a funnel for legions of newcomers and therefore a channel for new ideas and divergent points of view. The great port city that grew at its southern entrance became a center of trade and industry, a home to millions of immigrants, and a magnet for creative people of all kinds—financiers, industrialists, craftsmen, writers, artists, entertainers, intellectuals.

The foundation for all this was the state's ability to move goods and people quickly and cheaply. The Hudson Valley, because it had easy access to the sea, and New York City, because it was on the sea, began to grow and prosper soon after independence was achieved. By 1820 the older villages along the Hudson had become small cities, and groups of New England merchants moved into the valley to create new cities, such as Hudson and Troy, as inland seaports. The biggest of the

river ports, Albany, had over 12,000 inhabitants in 1820—a number exceeded only by the Atlantic seaports—and New York City, with 120,000 inhabitants, had become the nation's largest city.

The land speculators, who had acquired all of central and western New York by 1800, and the settlers who rushed in by the tens of thousands to buy these lands also depended on rivers for access to the sea—down the Susquehanna to Baltimore, down the St. Lawrence to Montreal, and, of course, along the Mohawk and Hudson rivers to New York. The earliest canals, which bypassed rapids and connected rivers with lakes, did not compete with river travel but improved it; the major turnpikes led not to the sea but to river ports such as Newburgh and Kingston. The grandest construction project of all—lauded in song, story, paintings, and in the history of civil engineering—connected the Mohawk-Hudson axis to Lake Erie and thus to the American Midwest. New York State, changing rapidly anyway, was never the same again. Construction of the Erie Canal, some 360 miles in length, began in 1817 and was completed, with enormous fanfare, in 1825. People and commodities, especially bulk products like grains, could be transported more cheaply than ever before. New people moved in to take jobs on the canals (it took 30,000 boatmen and longshoremen to run the Erie alone), and vil-

L.F. Tantillo, *Robert Wiltsie* [1989] (Robert and Mary Alice Bouchard).

L.F. Tantillo, *Montauk* [1989] (David and Mary Smith).

lages on the canal grew into cities. Buffalo became a major lake port, a transshipment center, and eventually an industrial city. Utica and Albany grew almost as rapidly, and the villages of Syracuse and Rochester became major cities. New York City was further transformed. Closer to Europe than other American seaports and now serving a vast hinterland, it soon became a world-renowned urban center and port of entry—not only for the world's goods but for millions of its people.

Other changes came rapidly. The Erie Canal was only five years old when the Mohawk & Hudson Company completed the state's first railroad line, which ran from Albany to Schenectady. By 1842 Albany was connected by rail with Buffalo and soon thereafter with New York City. Railroads, which had the advantages of greater speed and year-round operation, while canals were frozen in winter, eventually dominated the state's transportation network, but they did not quite kill the canals. Bulk goods—grains and coal and, in later years, petroleum—still traveled cheaper by canal. Besides, canals were imbedded in the New York psyche. In 1882 the legislature eliminated all canal tolls and in 1903 agreed to spend $100 million to improve the Erie Canal, which re-emerged in 1918 as the New York State Barge Canal. It is still with us.

In the meantime, as the canal-railroad competition suggests, the state's well-being, like that of the nation in general, was profoundly affected by the technological changes that were the dominating feature of the nineteenth century. The first of these, the steam engine, was actually an ancient device that had been improved to pump water out of mines. When applied to ships and boats, it reduced a voyage between Europe and New York from several weeks to several days and a voyage between New York and Albany from several days to a dozen hours. When applied to locomotives, the steam engine was even more impressive as it sped trains along the ground at forty miles per hour and sometimes faster.

Life began to change for New Yorkers. Steamboats and trains, not dependent on wind or wave or tide, made scheduled journeys possible, and schedules led to the widespread use of clocks—instruments of little use in previous eras—and a sense of measured time. Because they were independent of water courses, steam locomotives could go anywhere. The New York Lake Erie & Western Rail Road defied a centuries-old pattern in 1852 when it skipped the Hudson-Mohawk gateway completely and opened a railroad that ran from the metropolitan area directly across New York's southern tier to Lake Erie. Shorter lines brought railroad service to hundreds of small communities, and in the 1880s electric railway lines connected hamlets to villages and villages to urban cen-

ters in an unprecedented fashion, while surface trolleys and subways provided rapid transit within cities and made possible the rise of suburbs.

And then, with this system barely in place, the automobile appeared. At first a curiosity, a toy for the well-to-do, the auto eventually became reliable and less costly and then an absolute necessity. By 1915 there were 255,000 registered automobiles in New York State. By 1930 there were 2,330,000. By then the state was spending $109 million a year on highways. Numbers alone, however, cannot reveal the overwhelming effect of these various machines as they sped people and goods throughout the state, led to the concentration of industry in fewer and fewer centers, and therefore stimulated the rise of cities and the gradual depopulation of rural areas.

Life was further complicated by a discovery made many years earlier by a young Albany physicist named Joseph Henry. In 1831 Henry discovered the principle of electromagnetic induction, which led to the development of the electric motor and the dynamo. These devices brought about more changes in the next century than the world had seen in the previous twenty centuries. First came the telegraph, which transported words in seconds rather than in days or weeks, and then the wireless, which made it possible to broadcast words and music, and then the gramophone and the movies, which enabled anyone

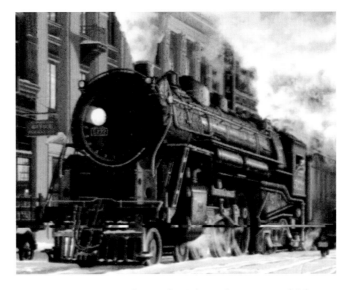

L.F. Tantillo, detail, *Washington Street, Syracuse, N.Y.* [1996] (KeyBank).

to experience sounds and sights that were hitherto reserved to the favored few, and the incandescent bulb, which translated electricity into light. Less dramatic but at least equally important, the electric motor quietly sped production in thousands of industries and lowered the cost of books, newspapers, and hundreds of related products. It was still better to be rich than to be poor, but experiences unavailable to kings a few years before were now within the grasp of almost everyone.

Through all these changes—thanks to the blessings of its geography and the industry of its people—New York had become, in substance as well as slogan, the Empire State. Beginning with the tens of thousands of New Englanders who poured up the Hudson and along the

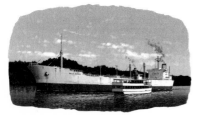

L.F. Tantillo, *Nile River* [1989] (Bill and Mary Ellen Siebert).

Mohawk for several decades after 1790, the state welcomed wave after wave of immigrants—at first from the British Isles, Ireland, and northern Europe; after the Civil War, from southern and eastern Europe; and after the Spanish-American War, from Spanish-speaking regions and the Far East. In addition, the twentieth century witnessed a great migration of African Americans from the American South to the cities of the North, including New York City.

As a result of immigration and natural growth, New York by 1930 had become the most populated of the American states, with over twelve million residents, and in economic strength it surpassed many nations. The state by then was more urban than rural. The new industries created by steam engine and dynamo had transformed Buffalo and the old canal cities into minor metropolises, and New York City held more than half the state's population—nearly seven million people. Local genius and a large population made New York State, with New York City at its cultural center, a leader in those industries and arts that the dynamo made possible and that are most associated with the twentieth century. The nation's first radio station, WGY, began operating in Schenectady in February 1922. WEAF in New York City was in operation later that year, and the city, with the

1919 creation of RCA and the 1926 creation of NBC, soon became an electronic communications center—a natural development since it had long been the nation's leader in journalism, the arts, and entertainment, including for a time the young movie industry. New York also led the nation in finance, the commercial arts, and architecture.

The skyscraper, in fact, became a symbol of the city, if not the state, and the construction of the Empire State Building, which opened in 1931, is an appropriate emblem to mark the end of a particular segment of the state's history. At that very time, however, something else was beginning. The aviation industry, attracted by the flat plains of Long Island, had taken early root in the state, and by 1931 scheduled passenger flights served the state's bigger cities. The piston-driven airplanes were small and slow by modern standards, but the route they followed connected past to present: they flew from New York City up the Hudson Valley to Albany, then west along the Mohawk and the old canal route to Syracuse and Rochester, and then on to Buffalo. Some things never change.

*Wendell Tripp is the director of publications, New York State Historical Association, Cooperstown, and the editor of* New York History.

# Visions of New York State

## THE PAINTINGS AND THE WORDS OF THE ARTIST

# Winter in the Valley of the Mohawk

This project began with the decision to depict a specific Mohawk site in western New York. Dean Snow, who was at that time professor of anthropology at the University at Albany, had for many years been compiling data on Mohawk communities. He directed me to various sites in Montgomery County where native villages had once stood. My wife, Corliss, and I made several trips to these locations, taking photographs and making careful notes. The site that most impressed me was the side of a steep slope facing the

Conceptual sketch, L.F.T.

Mohawk River. Snow's notes indicated that about two hundred people lived there from about 1625 to 1645. The view was breathtaking. I decided to orient my painting in such a way that the Mohawk River and the distinct mountain profile called Big Nose would appear in the distant background.

Winters in upstate New York can be severe. Deep snow and days on end of subzero weather are not at all uncommon. Wind chills of forty to fifty degrees below zero can cause frostbite within minutes. I began wondering what life must have been like for the Mohawks under such harsh conditions. I started making sketches and color studies.

My painting would be set at dusk on a cold and snowy January afternoon. The painting would focus on two hunters on snowshoes, who have been out all day looking for game. I wanted them to look cold and tired. To enhance the frigid atmosphere I used a vibrant shade of blue to simulate the luminosity that sometimes seems to radiate from patches of fresh-fallen snow at nightfall. I did not want the painting to be altogether bleak; after all, the hunters had worked hard and managed to catch a wild turkey. Contrasting color is sometimes an effective means of communicating temperature differences, so I painted the longhouses bathed in the red-orange glow of some unseen campfire. The warmth of the light exaggerates the conditions of the cold winter night and also promises the men a reward for their work. By placing the source of the

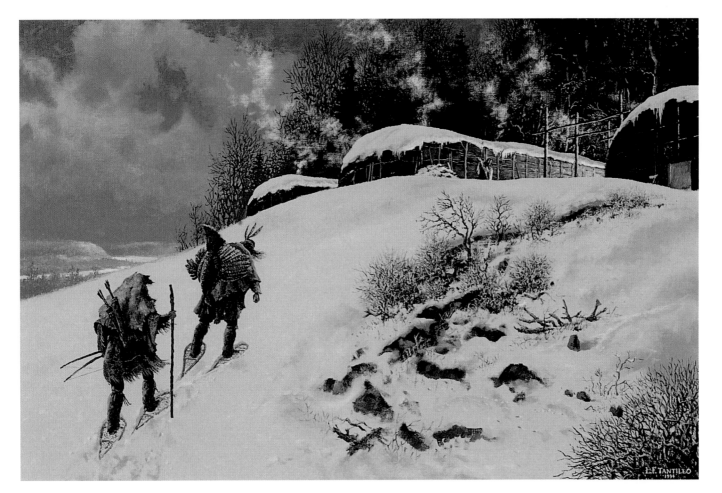

**Winter in the Valley of the Mohawk**

Acrylic on canvas, 20 x 30 in.
Signed and dated lower right:
L.F. Tantillo, 1994

COLLECTION
Victor and Lyn Riley

light outside the image area, I encouraged the viewer to imagine the rest of the scene. In the final painting I added a female character. She is concerned and has been waiting for some time. Upon noticing the returning hunters, she excitedly announces their return to the rest of the camp.

*Winter in the Valley of the Mohawk* is not a painting that deals with the spiritual life of the Iroquois. It does, however, attempt to communicate to the viewer the love and dedication people have for one another, which is not diminished even by the harshest conditions. This is a simple truth that transcends time and culture. It is the bridge of human emotion that transports the viewer back to that long-ago village overlooking Big Nose. This is the com-

mon denominator of the human experience that binds us all together and allows us to imagine ourselves in this painting.

A view of the Mohawk River looking east.

This drawing by Charles Bécard de Granville, a French official in Canada, was done circa 1700. It is among the earliest and most authentic depictions of the Iroquois. This highly tattooed figure is very probably a Mohawk of the Turtle clan. His hairstyle and feathers became the basis for the lead hunter in my painting.

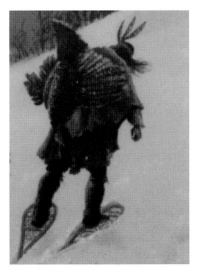

Cet Jcy un —
depûte du bourg de gannachiou-
avé poursfilles invités au feu les —
Messieurs de gandaouguega —
Ils tiennent que les sus portent
le dieu du peuple l'invoquent
le tenant en main en dansant
et chantant.

THE SETTING:
The village depicted in the painting was in Montgomery County, New York. A more specific location is not provided to preserve and protect this site for further archeological study.

# The Trading House, 1615

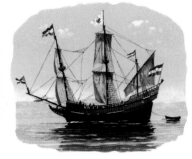

L.F. Tantillo, *The Halve Maen* [1989] (Christopher L. Anderson).

Henry Hudson's voyage of 1609 opened the doors of exploration to Dutch fur traders in the Hudson Valley. In 1614, Hendrick Christiaensen built what by all historical accounts was the first non-native structure in the state of New York. Christiaensen was working for the Van Tweenhuysen Company and was in command of their ship *Fortuyn*. Remarkably, he had been successful at trading with both the Mohawk and the Mohican people, two native tribes that had a long-standing and fierce hatred of each other. Business had been so good that a structure was needed to store furs and house a small group of men who would remain behind and continue trading after their ship returned to Holland. This trading house was named Fort Nassau, in honor of Prince Maurice of Nassau, States General of the Netherlands. It was located on Castle Island (now Albany). In 1617 the fort was destroyed by a flood, and before Christiaensen could rebuild it he and most of his crew were killed in an Indian attack south of Albany. Fort Nassau historically marks the beginning of the develop-ment of New York State by Europeans. Fort Nassau was an interesting and challenging subject to paint. No one who actually saw the fort left behind even the sketchiest graphic evidence. There are, however, many verbal descriptions, including some construction specifications. To help interpret this information I sought the assistance of three noted historians, Paul Huey, Charles Gehring, and Shirley Dunn. Each of them had made serious schol-arly studies of Fort Nassau. Together they helped me to formulate a speculative design for the fort.

Once the configuration of the structure was estab-lished, many sketches were made to determine the point of view. After looking at several alternatives, I chose a position to the south and west of the fort, at slightly

L.F.T.

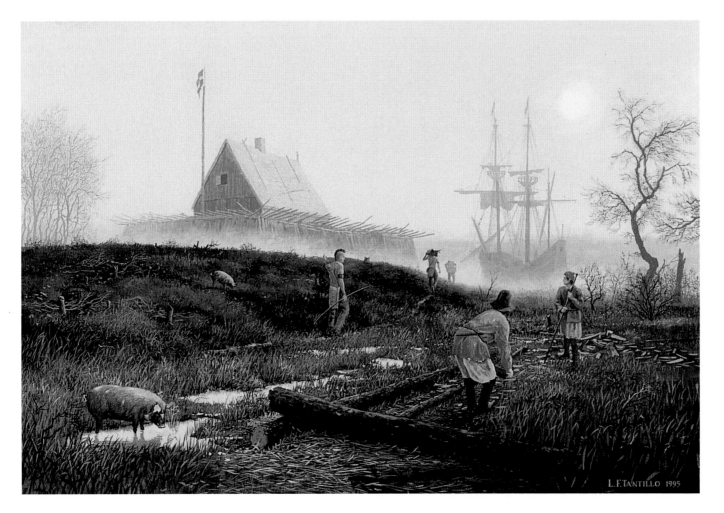

**The Trading House, 1615**

Acrylic on canvas, 20 x 30 in.
Signed and dated lower right:
    L.F. Tantillo, 1995

COLLECTION
David A. Wolfe

41

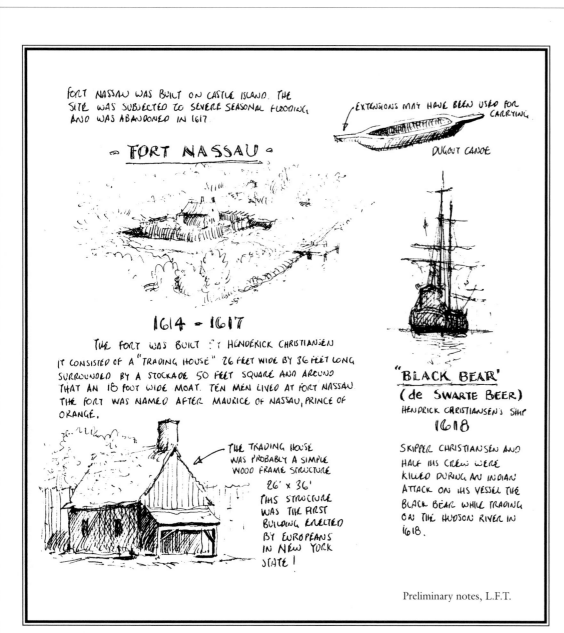

FORT NASSAU WAS BUILT ON CASTLE ISLAND. THE SITE WAS SUBJECTED TO SEVERE SEASONAL FLOODING AND WAS ABANDONED IN 1617

EXTENSIONS MAY HAVE BEEN USED FOR CARRYING

DUGOUT CANOE

## ° FORT NASSAU °

### 1614 - 1617

THE FORT WAS BUILT BY HENDRICK CHRISTIANSEN

IT CONSISTED OF A "TRADING HOUSE" 26 FEET WIDE BY 36 FEET LONG SURROUNDED BY A STOCKADE 50 FEET SQUARE AND AROUND THAT AN 18 FOOT WIDE MOAT. TEN MEN LIVED AT FORT NASSAU. THE FORT WAS NAMED AFTER MAURICE OF NASSAU, PRINCE OF ORANGE.

THE TRADING HOUSE WAS PROBABLY A SIMPLE WOOD FRAME STRUCTURE

26' x 36'
THIS STRUCTURE WAS THE FIRST BUILDING ERECTED BY EUROPEANS IN NEW YORK STATE!

"BLACK BEAR"
(de SWARTE BEER)
HENDRICK CHRISTIANSEN'S SHIP
1618

SKIPPER CHRISTIANSEN AND HALF HIS CREW WERE KILLED DURING AN INDIAN ATTACK ON HIS VESSEL THE BLACK BEAR WHILE TRADING ON THE HUDSON RIVER IN 1618.

Preliminary notes, L.F.T.

below eye level. This placed the river in the background and out of sight, except for Christiaensen's ship, the *Fortuyn*. To create the atmosphere of mystery and loneliness that the small group of Dutch sailors must have felt, I set the painting on a misty morning in November. The more distinct features of the foreground emphasize the cleared wetland. A small band of Mohawks has come to trade, while two crewmen work at cutting wood. For a moment the men exchange curious and apprehensive glances. A great change in this native world had begun. It would never be the same again.

Dutch figure study, L.F.T.

The preliminary pencil sketch that formed the basis of the final painting. This medium was most helpful in getting a sense of the relative values of light employed to establish the misty character of the work.

THE SETTING:
The trading house, which was called Fort Nassau, was located on Castle Island, now part of the Port of Albany. The exact location of this site has never been established.

After Fort Nassau was destroyed in 1617, the Dutch government regulated trade in the Hudson River Valley through the newly established Dutch West India Company. In 1624 it was decided that a permanent settlement would be constructed near the site of the old fort. The new fur-trading colony was named Rensselaerswyck in honor of the man who owned and operated it, Kiliaen van Rensselaer. Walloon colonists from the Netherlands were sent to build the colony's principal structure, Fort Orange. The fort was located on a bend in the river 3,500 feet north of Castle Island. The land was already cleared and had been used for some time by the Mohicans. The fort was built of wood, in a square configuration with a bastion at each corner. The bastions were filled with dirt, thus elevating them and creating a platform from which cannons and muskets could command a more effective field of fire. The perimeter excavation that yielded the dirt for the bastion infill itself became a defensive element, serving as a dry moat. The total area inside the curtain walls might have been as little as 12,000 square feet or as great as 20,000 square feet.

A Dutch map of Rensselaerswyck drawn in 1632 clearly indicates the fort standing on the river's edge in an area of cultivated flats. The moat that surrounds the fort on all but the east side, next to the river, is visible. Specific plans for this fort are not known to exist. This fort, however, was built on the same general plan as numerous other Dutch facilities around the world.

The early records also show that during the administration of Wouter Van Twiller, from 1633 to 1638, Fort Orange was refurbished. The new construction consisted of an elegant large house, with a flat roof, balustrade, and lattice work, and eight small houses for the soldiers. Additionally, during this period a ship's carpenter by the name of Tymen Jansen built the yacht *Omwal* outside the fort.

In 1643, the French Jesuit missionary Father Isaac Jogues escaped from the Iroquois, who had captured him. The Dutch hid the priest in Fort Orange until he could

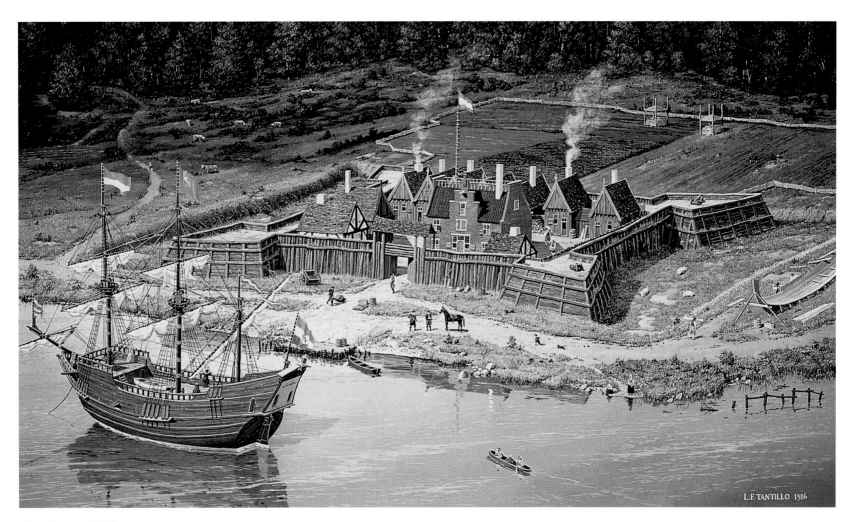

***Fort Orange, 1635***

Acrylic on canvas, 24 x 36 in.
Signed and dated lower right:
   L.F. Tantillo, 1986

COLLECTION
Michael B. Picotte

This sixteenth-century Dutch engraving depicts a Fort Orange located on the Rhine River near Emmerich, Germany. Historians believe that the Albany fort was similar in design, particularly in the layout of buildings within the walls of the fort.

*Below:* Dutch map of Fort Orange, circa 1630 (Library of Congress, Map Division).

*Below left:* The location of Fort Orange in present-day Albany. Note the massive entanglement of traffic lanes along Interstate 787.

*Below right:* Period line drawing depicting a four-bastioned fort in Banda, India. The design pattern for these Dutch facilities varied little the world over.

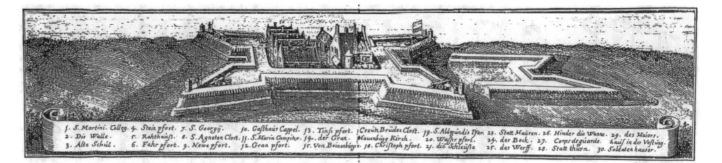

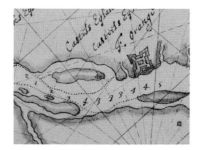

depart for Europe. Jogues described the fort as "a wretched little fort named Fort Orange—built of logs with four or five pieces of Breteuil cannon and as many swivel guns." Fort Orange went on to serve as a center of Dutch inland trade until it was captured by the English in 1664. In 1676 the fort was abandoned.

Information from numerous sources provided the basis for this painting. Details were obtained from the archeological findings uncovered by Paul Huey for the New York State Historic Trust in a partial excavation of the Fort Orange site in 1970. Additional material was gathered from studies of similar Dutch installations in Europe, North America, South America, and Asia. Seventeenth-century Dutch paintings and drawings provided much of the information pertaining to building details, ship construction and rigging, clothing, and vari-

ous site embellishments. Many hours of consultation with historians from different disciplines brought all the pieces together into a coherent form.

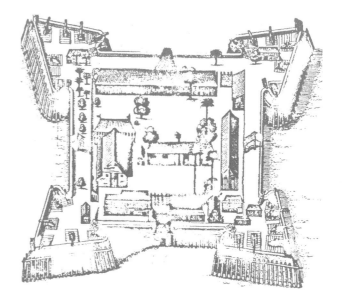

Fort Orange was located near the corner of Broadway and Madison Avenue in present-day Albany. The site is identified by a small bronze plaque. The actual remains of the structure are buried under the traffic lanes of Interstate 787.

A. *Earlier structures*. Some buildings that had been erected when the fort was constructed in 1624 probably remained in use through this period.

B. *Company house*. The "elegant large house with flat roof" used as quarters for administrators, fur storage and general Dutch West India Company business.

C. *Housing*. Simple, small wooden houses served as quarters for Dutch West India Company personnel.

D. *Bastions*. Corner bastions constructed of wood with dirt infill were used as defensive firing platforms.

E. *Cannons*. Small bronze three-pounder cannons mounted on ship's carriages with oversized wheels could be moved easily from bastion to bastion. The fort had four or five such guns, which were usually kept stored away.

F. *Curtain wall*. Wooden wall with dirt back-fill protected internal buildings and allowed access from bastion to bastion.

G. *Dry moat*. Depression created by excavation of earth for bastions and curtain wall infill. The moat existed on three sides only.

H. *Boat building*. Tymen Jansen building the yacht *Omwal*.

I. *Indian traders*. Mohican traders delivering furs in a dugout canoe.

J. *River*. The Hudson River at high tide with southwest wind.

K. *Ship*. A Dutch West India Company merchant ship, possibly the *Eesdracht*, anchored directly in front of the fort.

L. *Ship's flags*. Holland state flags fly from the jack staff (bow), foremast and main mast. A Dutch pennant flies from the mizzen mast and a Dutch West India Company flag from the ensign staff (stern).

M. *Pastures*. Livestock were allowed to roam freely. Various markings such as the clipping of a pig's ear identified owners.

N. *Board fence*. Used to keep animals out of cultivated areas.

O. *Cultivated land*. Tobacco, barley, cabbage, and wheat were among the crops grown at this time.

P. *Hay barracks*. An early type of hay storage structure with an adjustable roof.

# Fort Orange: An Archeologist's Perspective

## Paul R. Huey

L.F. Tantillo, *Fort Orange (low angle sketch)* [1986] (artist's collection).

Fort Orange was built by the Dutch West India Company in 1624. The only known original plan of the fort is a small detail on a map of Rensselaerswyck drawn about 1632. It shows that the fort had four bastions projecting from the corners and was surrounded with a wide moat. On three sides were cultivated river flats, and the Hudson River was to the east. Between 1633 and 1638, eight small houses for soldiers were built in the fort, in addition to an elegant, large trading house.

The fort had to be evacuated temporarily during a great flood at the end of April 1640. In 1647 the Company allowed Jan Labatie to build a small brewery just inside and to the left of the east entrance. Unfortunately, in the spring of 1648 another great flood "almost entirely washed away" the fort. Governor Stuyvesant began to rebuild the fort with stone, a project he could not complete, and he allowed private traders to build houses in the fort against the inside curtain walls. A short distance to the north and separate from Fort Orange, Stuyvesant also laid out the town of Beverwyck. The English took Fort Orange during peacetime in 1664 and renamed the town Albany;

Fort Orange became Fort Albany. The English finally abandoned the fort in 1676, building a new fort on the hill above the town.

Traces of Fort Orange remained clearly visible in the open pastures south of the city of Albany for almost 140 years after 1676. A British engineer measured the outline of the fort in 1766 and found that it was 140 feet, 6 inches in length along the river and 125 feet in depth. The people of Albany were well aware of the historical significance of the site. It held a very strong symbolic meaning for them, and they refused to allow the British military to disturb it. With cannon mounted on the earthen remains, they saluted Independence Day on July 4, 1784, and the state's ratification of the Constitution in 1788. As the city expanded southward over the site after 1790, Surveyor General Simeon DeWitt carefully recorded the visible outline of the fort on the city survey map, and then he built his own new house on part of the actual site. Vestiges of the fort, probably in DeWitt's back yard, were still visible in 1812.

Soon, an additional block of new land was created by dumping fill into the Hudson River east of DeWitt's house, and Quay Street was laid out

along the new river bank. The broad space in front of DeWitt's house became Steamboat Square, which served as a landing place for steamboats arriving from and leaving for New York City. The memory of the exact location and position of old Fort Orange remained strong, however. In 1886 the Albany Bicentennial Commission mounted a bronze tablet on a granite block with an iron railing around it in Steamboat Square, correctly marking the site of the northeast bastion of Fort Orange.

The city of Albany began turning its back on the Hudson River in 1914 as construction of the Delaware & Hudson Building commenced. On Steamboat Square railroad sidings were built, and the 1886 tablet was moved a short distance. However, it was not until the Great Depression in the 1930s that drastic changes obliterated Steamboat Square, altered street locations, and cut the slender thread of public memory of the site of Fort Orange. In 1932 a substantial concrete abutment for the Delaware & Hudson railroad tracks was built along the river, which not only required deep ground disturbance—destroying much of the archeological remains of the fort—but also completed the separation of the

city from the river. The 1886 tablet was moved north, away from the site of Fort Orange, and was installed in a pedestrian subway passing under the tracks. Subsequently, even historians were unsure of where Fort Orange had stood.

In 1970, after carefully tracing these many changes backward to reestablish from nineteenth-century records the location of Fort Orange, this writer, with the support of the New York State Historic Trust, on the morning of October 20 directed the digging of a test hole at a preselected, measured location near the 1932 railroad abutment. Later that day we discovered the first Dutch artifacts dating from the period during which Fort Orange was occupied. This was the beginning of the first archeological excavation of an extensive seventeenth-century Dutch colonial site in America. Because Interstate 787 was soon to be constructed across and through the site, the New York State Department of Transportation supported a concentrated archeological project lasting into March 1971 to rescue the artifacts and information from the site that would otherwise have been disturbed or destroyed.

The excavations uncovered a section of the south moat and parts of three structures that had been built inside the east curtain wall of the fort. Fortunately, Dutch land records could be used to identify these structures as some of the houses that were built after the flood of 1648. The remains of the wall itself had been destroyed by the construction in 1932. Remains that were found to date from before 1648, however, included the packed pebble-and-clay pathway, which is believed to have led from the east gate, and, adjacent to the pathway to the south, parts of a brick-and-cobblestone foundation. This foundation initially was thought to be the remains of Jan Labatie's brewery, until Janny Venema of the New Netherland Project in 1990 discovered a previously unpublished document giving the dimensions of the Labatie building. This showed that it would have been outside the excavation area, in the area destroyed in 1932. The brick-and-cobble foundation must have been part of a guard house or some other gateway structure near the entrance of the fort. Many of the artifacts that were found in these excavations are now on public display across the river at Crailo State Historic Site, a museum of the Dutch in the upper Hudson Valley.

L.F. Tantillo's painting of Fort Orange shows the fort as it might have looked in 1635. The archeological excavations not only confirmed the general size and probable plan of part of the fort after 1648 but also demonstrated that the Dutch spared no effort in bringing high-quality building material and other artifacts to the site in an effort to recreate completely the way of life they had known in the Netherlands. This information had been unavailable to all previous artists who had attempted to depict Fort Orange. Their work was clearly outdated, perpetuated old stereotypes, and did not have the benefit of results from modern research methods, including archeology. Tantillo utilized the new insights and the new information derived from archeology to the fullest extent possible. Thus, the central brick trading house shown in the painting surely was built in a Dutch style suitably representing the power and prestige of the West India Company. The eight houses for soldiers most likely were built along the west wall of the fort, since apparently no houses of private traders were ever built there. The half-timbered house at the far left in the painting occupies a space probably occupied by a store house or some other structure in 1635, but the archeological excavation at that location revealed only the later wooden cellar of a house, probably built about 1651 by Hendrick Andriessen van Doesburgh as part of the redevelopment of the fort after the flood of 1648. The site of the half-timbered building to the right of the entrance against the east curtain wall became the locations of the Staats house of about 1648 and the Hans Vos house of the 1650s. No information from documents or from subsequent analysis of the archeological data has yet come to light to indicate that this painting does not show Fort Orange and capture the atmosphere of its setting just as it might have appeared in 1635.

*Paul R. Huey is the former Senior Scientist (Archeology), New York State Office of Parks, Recreation, and Historic Preservation and was director of the Archeology Research Program at the New York State Historic Sites for nearly thirty years.*

# The Bradt Sawmill, 1660

n the banks of a fast-moving stream south of Fort Orange, in 1637, Pieter Cornelisen and Albert Andriesen Bradt built Rensselaerswyck's first successful sawmill. Shortly after the construction of the mill, the partnership of Bradt and Cornelisen abruptly ended. Cornelisen operated the mill from the mid-1630s until it was taken over by Albert Bradt in 1646.

Bradt was hardly the most popular citizen in the community, judging from his numerous court appearances over petty disputes. He had arrived with his first wife, Annetje, in 1637 and had earned a livelihood as a tobacco planter, fur trader, and fisherman. In 1646, Bradt took over the operation of the sawmill. He was the master millwright for twenty-six years, selling the business in 1672. He was married three times and had eight children. He died in 1686 at the age of 79.

So little is known of the appearance of Bradt's sawmill that any attempt to paint it becomes highly speculative. Several major assumptions were made at the onset of this work. The mill was less than ten years old when Bradt took it over, and he had control of it for a substantial amount of time. Alterations would probably have occurred. Albert Bradt was not Dutch but Norwegian, and therefore his architectural influences would have been Scandinavian. I was able to find several examples of sawmills from Bradt's homeland in this period. A few of these structures had very obvious additions and alterations. My speculative circa 1660 mill is derived from those sources.

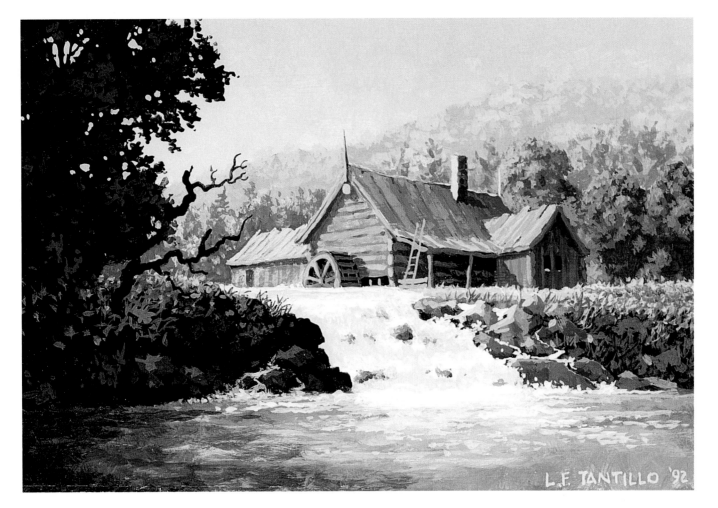

*The Bradt Sawmill, 1660*

Acrylic on panel, 9 x 12 in.
Signed and dated lower right:
  L.F. Tantillo, 1992

COLLECTION
Kenneth Bradt

# The Taking of New Netherland

**Joseph F. Meany**

Sketch of Dutch cannon from Fort Orange, L.F.T.

King Charles II had been restored to the British throne in 1660, and with him his royal brother James, Duke of York and Lord Admiral of England—and James cast covetous eyes on Dutch New Netherland. Opportunity came, in 1664, with the outbreak of the second Anglo-Dutch maritime war. A squadron of three warships and a transport, totaling ninety-two guns, sailed from Portsmouth under the command of Sir Richard Holmes.

Aboard the transport *William and Nicholas* were three companies of infantry, about 475 men, drafted secretly out of the Duke of York's own Maritime Regiment of Foot, forerunners of the Royal Marines. They were commanded by Sir George Cartwright, Sir Robert Carr, and Colonel Richard Nicolls, who was designated ground force commander. His ostensible mission was to seize the charter of Massachusetts Bay and reduce that Puritan colony to obedience to the restoration government of King Charles II.

The squadron reached Boston but then sailed on to New Amsterdam, where, on August 30, 1664, Colonel Nicolls demanded the surrender of the Dutch colony. When Director-General Pieter Stuyvesant stalled for time, Nicolls landed troops at Gravesend Bay and, marching along the Brooklyn shore, linked up with militia from the New England towns of eastern Long Island. The crisis was brought to a conclusion when the frigates HMS *Guines* (thirty-six guns) and HMS *Elias* (thirty guns) and the sloop-of-war HMS *Martin* (sixteen guns) anchored off Nut Island (now Governor's Island) and trained their broadsides on the fort. On September 8th Stuyvesant surrendered.

Two days later Sir George Cartwright, with one company of marines—perhaps fifty officers and men—sailed 160 English miles upriver to take possession of the Dutch trading post at Fort Orange. There the Dutch garrison, no more than a dozen men, accepted the inevitable without resistance. Beverwyck became Albany. Meanwhile Sir Robert Carr's company aboard *William and Nicholas,* escorted by HMS *Guines,* sailed for the Delaware to reduce the Dutch fort there.

*Joseph F. Meany is Acting State Historian at the New York State Museum, Albany, and a military history specialist.*

Political transitions alter the destiny of nations. The capital district of New York State was once Mohican territory. In 1624, the Dutch acquired the land from its former inhabitants and began building the colony of Rensselaerswyck. Forty years later, in August 1664, Fort Orange became Fort Albany. The Dutch garrison surrendered to a company of English marines without firing a shot, and for the next century the colony was under British rule.

In 1989, I was working on a series of paintings that depicted the maritime history of the upper Hudson River. I wanted to include the British vessel that sailed up the river and captured Fort Orange. I contacted the noted historian Paul Huey, senior scientist (archeology) at the New York State Bureau of Historic Sites. Huey had discovered documentary evidence in the *Calendar of State Papers, Colonial Series, America and the West Indies, 1661–1668*. He showed me the abstract of a letter from Colonel Walter Slingsby to a man named Williamson (p. 256), which had reported that

> Henry Miller, boatswain of the *Elias,* gives particulars of the taking of New Netherland; after taking the place they went 40 leagues higher and took Fort Aurania (Orange), which they called Fort Albany; Sir Robert Carr went to Dilloway [that is, the Delaware] and surprised another Dutch fort. The *Elias* foundered coming from Sandy Hook on the coast of New England 140 leagues from shore.

Huey contacted the National Maritime Museum in Greenwich, England, and requested information on all British ships of that time carrying the name *Elias*. They replied with data from historic documents that included several ships by that name. The most likely candidate appeared on two lists. The "Rupert Jones List" mentioned *Elias,* 36, Commonwealth Navy, captured 1653, wrecked 1664. Another account entitled "Lists of Dutch Men-of-War, 1648–1702" gives *Elias,* 36, captured by the English, 1653. It would appear from these two sources that, ironically, the Dutch colony was captured by a reflagged Dutch warship.

We concluded from this material that a thirty-six-gun, Dutch-built English warship named *Elias* sailed up the Hudson River and captured Fort Orange. Joseph Meany, senior historian at the New York State Museum, disputes this conclusion on the basis of scale. He believes the

**Elias, 1664**

Acrylic on panel, 8 x 10 in.
Signed and dated lower right:
 L.F. Tantillo, 1989

COLLECTION
Thomas and Mary Rabone

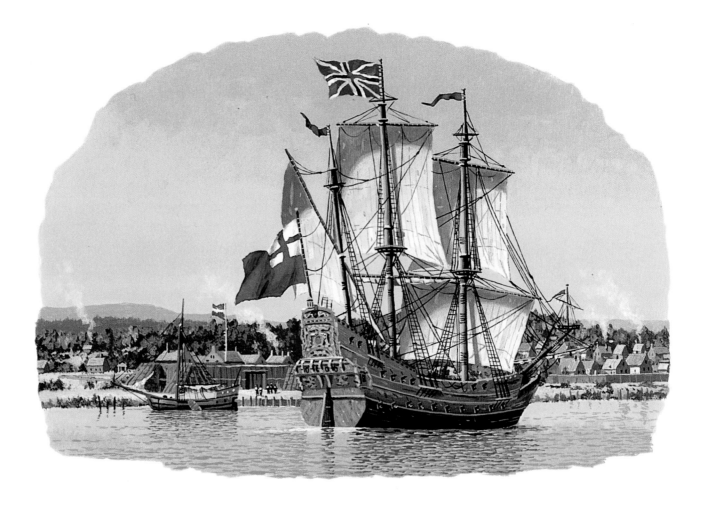

54

British would have dispatched their smallest warship, the HMS *Martin*, a sixteen-gun sloop-of-war, to take the lightly armed fort. Additionally, Meany believes the *Elias* was too deep in the hold to have been the ship. The greatest navigational obstacle on the upper Hudson at that time was the Overslaugh Bar, near present-day Castleton. Meany believes that the *Elias* would have drawn far too much water to clear the bar. Engineers involved in the dredging of the channel in the early 1900s speculated that the shallowest point on the Hudson at the Overslaugh Bar prior to alteration would have been approximately thirteen feet of water at high tide.

Although I have the greatest respect for Meany's research, it could not convince me that Colonel Slingsby's letter could be describing any other ship but the *Elias* in the taking of Fort Orange. Regarding the issue of depth, Dutch ships are noted for their shallow drafts. One of the largest and most famous Dutch warships of the time was the *Zeven Provincien*. It carried eighty guns, including thirty forty-two-pounders, and a crew of 743 men. The three-decker ship measured 203 feet long and 42 feet wide, and yet the ship's draft was only 14 feet, 6 inches. *Elias* was probably close to half the size and nowhere near

the weight of the *Zeven Provincien*, with a depth between 9 and 12 feet. I believe a skillful pilot in a vessel of that size could have navigated past the bar.

The actual design of the *Elias* used in the painting came from a series of speculative assumptions. Since *Elias* carried thirty-six guns, it would probably have been considered a frigate. The ship was of Dutch design and was built before 1653 (the year it was captured by the English). There are some very detailed drawings of a Dutch frigate named the *Vrijheijt* (Liberty) built in 1651 for the Amsterdam Admiralty. In the years that followed its construction, the *Vrijheijt* was used as a model for other frigates. I based my *Elias* on the drawings of that ship.

THE SETTING:
The painting depicts a view from the Hudson River looking west at Fort Orange and the community of Beverwyck—present-day Albany.

# Portrait of Stewart Dean

This nineteenth-century portrait of Stewart Dean was painted on the face of a brooch pin. It is the only contemporary image of Dean known to exist.

Stewart Dean was born on the fourth of July in 1747. He was a sailor and, in every sense of the word, an American patriot. In his early twenties he moved from Maryland to Albany, New York. At that time he commanded a small merchant ship and was engaged in the cargo trade between the colonies. He married Pietertje Bratt of Albany in 1773, but a quiet life on the Hudson River would have to wait. Dean was passionately committed to the spirit of independence. The times were unstable, and it was obvious that an open break with Britain was close at hand. He offered his services to the fledgling military forces of General Washington.

Within days of the signing of the Declaration of Independence, Dean had his first command, the privateer sloop Beaver, and was engaged in a naval battle in the Caribbean Sea. For the next five years Dean divided his time between naval duties and serving in the militia in Albany. In 1782 he was given command of a larger and more heavily armed vessel, the schooner *Nimrod*. In May of that year, while patrolling St. Christopher's Harbor in the West Indies, Dean was attacked by two twenty-gun British warships. After a short and bloody battle *Nimrod* was captured, and Stewart Dean fell seriously wounded.

He was held prisoner for twenty days, after which his freedom was secured through the negotiations of the governor of Antigua. In the closing year of the war, while Dean was back in Albany recovering from his injuries, his wife Pietertje died. One can only imagine the mixed feelings Dean experienced at that time.

In 1784, Captain Dean returned to the merchant trade and required a new ship. Near his house, on the banks of the Hudson River in Albany, he had a sixty-foot sloop built. He named the vessel *Experiment* and, after several commercial ventures, sailed her into maritime history. His famous voyage lasted one year and four months and covered 14,000 dangerous nautical miles. With the unbelievably small crew of seven men and two boys, *Experiment* became the second vessel in United States history to sail to China.

That voyage, combined with his distinguished war record, made him a living legend. He was celebrated as a hero for the rest of his long life. It was written that, of all the sloops available for transit on the Hudson River, the *Experiment* under the command of Stewart Dean was by far the most interesting, for aboard that vessel travelers were able to hear the captain's great tale of adventure in China.

In the years that followed, Dean lived a very content-

ed life in Albany. He married Margaret Whetten in October 1787 and built a new house on a hillside overlooking the river. His passenger and cargo business flourished. He enjoyed his large family of eleven children and thirty-one grandchildren. He looked on as the little town on the upper Hudson to which he had come as a young man grew into a thriving city. Many honors were bestowed on him in his later years, including the renaming of Dock Street to Dean Street. He watched his children lead successful, productive lives. It was a fitting reward for a lifetime of service and patriotism. On August 4, 1836, at the age of 89, Stewart Dean died in the company of his family.

When he was in his thirties, the only known image of Stewart Dean was painted from life on a small piece of jewelry. The portrait was done in a primitive style by an artist who apparently had little knowledge of the structure of the human head. As a part of a much larger project concerning the exploits of Captain Dean, I decided to do a new portrait, based on the period painting but utilizing the proper proportions of facial bone structure. I also wanted my work to have an eighteenth-century style. I reconfigured the earlier work without giving up the shape of Dean's eyes, nose, mouth, ears, and chin. The end result, I believe, is the credible face of a man I came to admire and respect as a true American hero.

*Portrait of Stewart Dean*

Acrylic on canvas, 11 in. oval
Signed and dated lower left:
  L.F. Tantillo, 1992

COLLECTION
KeyBank

# Voyage of the Experiment

For as long as human beings have inhabited its banks, vessels have been built on the Hudson River. The Mohicans built dugout canoes, and the Dutch built yachts. Brigs, frigates, gunboats, passenger steamboats, tugs, and everything in between slid into the waters of this great river. None, however, accomplished a more daring feat than the sixty-foot sloop from Albany, New York, named the *Experiment*.

Two centuries ago, after America had won its War of Independence, Stewart Dean, an Albany captain and war hero, had a single-masted freight boat built near his home on Water Street. Dean's sloop, *Experiment*, was a typical work boat of its day. The deck was wide and low, measuring 59 feet, 11 inches by 19 feet, 3 inches. The craft was registered at eighty-five and a half tons. *Experiment* cleared Albany in July 1784 on its maiden voyage. It car-

ried a full cargo of grain across the Atlantic to Madeira, where it was sold. There Dean loaded his ship with wine and a few head of cattle. He then sailed to the West Indies and traded his cargo for rum, which, in turn, was taken to Charleston, South Carolina, and sold. *Experiment* returned to New York in December of that year, completing its first successful commercial excursion.

The ventures that followed were less profitable. Dean needed a new approach. With the support of investors from Albany and New York City, he organized what was to become his most famous voyage.

In December 1785, Captain Dean, with a crew of seven men and two boys, set sail for Canton, China. Canton was the world's most prized port; it was the focal point of international commerce and, as such, attracted merchant vessels from all over the globe. Only one ship from the fledgling United States had made the journey before, the three-masted square-rigger *Empress of China*.

Loaded with supplies and trade goods, the well-armed sloop *Experiment* left Murray's Dock in New York City and made for the open sea. Braving storms and rough water and ever watchful for the treacherous pirates of the South China Sea, Dean arrived in Canton in June 1786. He remained there for six months and negotiated many lucrative transactions with the Chinese Hong merchants.

On December 10, 1786, Dean left Canton. He arrived

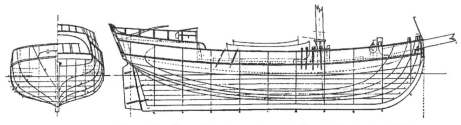

Plans of the Sloop *Experiment*, drawn by Charles Davis, circa 1932

58

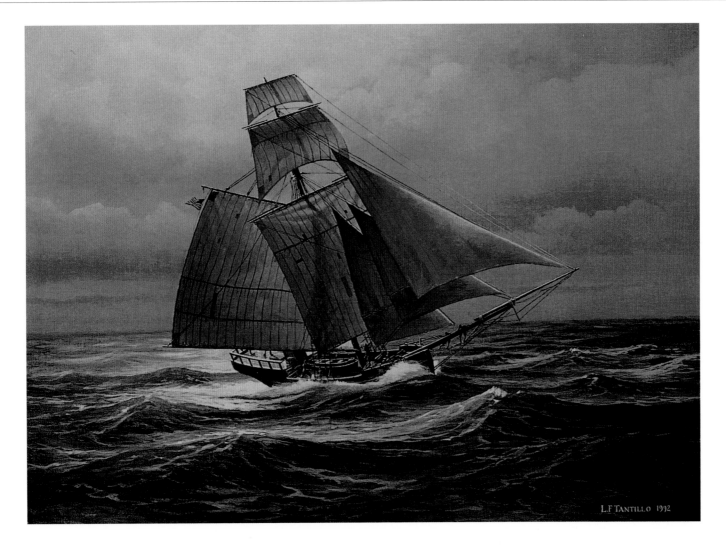

**Voyage of the Experiment**

Acrylic on canvas, 20 x 30 in.
Signed and dated lower right:
 L.F. Tantillo, 1992

COLLECTION
KeyBank

Howqua was the leader of the Hong merchants and considered to be the wealthiest man in the world. He was impressed by Captain Dean, and the two men formed a lasting friendship.

L.F. Tantillo, *Portrait of Howqua* [1992] (KeyBank).

back in New York City on April 20, 1787, one year and four months after his departure. There, the *Experiment* was greeted by a jubilant crowd, cannon salutes, and all manner of fanfare. Miraculously, all hands were safe and in good health. The cargo of teas, silks, and chinaware they had carried back was sold for a substantial profit, and the voyage was pronounced successful.

With Captain Dean in command, the *Experiment* returned to ply the Hudson River trade. In 1789, Hector St. John de Crevecoeur published his famous account, *An Eighteenth Century Journey through Orange County.* In it he commented on what an exhilarating experience it was to travel aboard the *Experiment.* He described the sloop's unusually large cabin, decorated in Chinese fashion with lighted candles in glass bowls. He was also quite impressed with Dean's love and appreciation for the

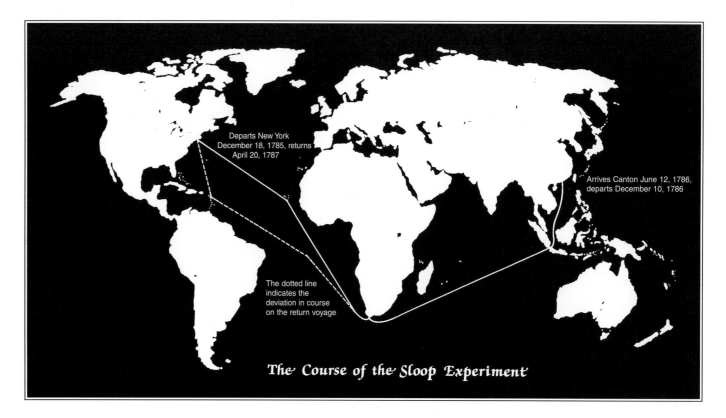

Departs New York December 18, 1785, returns April 20, 1787

Arrives Canton June 12, 1786, departs December 10, 1786

The dotted line indicates the deviation in course on the return voyage

*The Course of the Sloop Experiment*

William Laight, & Co.
Have for SALE, on reasonable
Terms for Cash,

HYSON TEA of the first quality,
SOUCHONG TEA, superior to any
hitherto imported,
NANKEENS, large pieces, and of the finest
kind,
CHINA WARE, elegant patterns, pencilled
and gilt.
Imported in the Experiment, Capt. Dean,
just arrived from China.
April 26, 1787                                    56

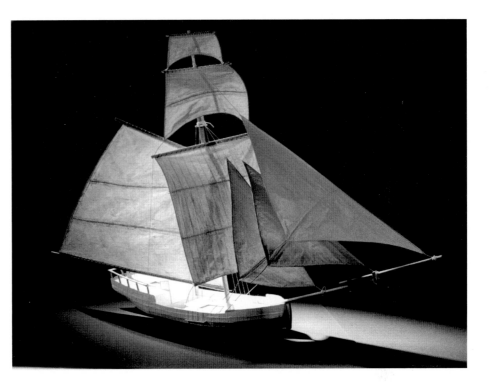

This is the model I built of the *Experiment*, made of white cardboard, wooden dowels, wire, and tracing paper. The sails are fully adjustable, allowing me to explore various configurations and lighting conditions. The finished model is approximately two feet long.

The newspaper advertisement (upper left) was used to sell the cargo from the *Experiment* in New York City.

beauty of the Hudson River and his knowledge of its history. However, the story in which the author was most interested was the captain's description of his great adventure to China.

My painting *Voyage of the Experiment* depicts the sloop as it might have appeared during the China voyage, somewhere in the Indian Ocean on a moonlit night. The wind is becoming dangerously brisk, and the crew is scrambling to cut sail before the wind snaps the sloop's bowsprit and mast. These were courageous sailors braving a variety of hazardous conditions on a very lonely sea, and it was my intention to portray that aspect of their amazing voyage.

# The Return of the Experiment

n the descriptions of the previous two paintings I explored the life of Stewart Dean and the accomplishments of his sloop, the *Experiment.* The final and major work in this series was a large painting commemorating Dean's triumphant return to his home port of Albany after his incredible voyage to China. Little is actually known of this event. Records seem to indicate that he may have returned to Albany in June 1787. The newspapers in New York City describe in detail his arrival there on April 20, 1787. Unfortunately the Albany newspapers carried only reprints of that article. I decided to depict a scene that represented his return sym-

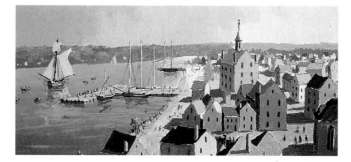

L.F. Tantillo, *Return of the Experiment (layout preliminary #1)* [1993] (Robert and Mary Alice Bouchard).

bolically but in which all the imagery was rooted in fact. This was more difficult than I had anticipated.

When I began the project, two very formidable problems presented themselves. This was the largest canvas I had ever attempted, and no one had ever before painted the eighteenth-century waterfront of Albany, New York. In other words, nobody knew what it looked like—and I was painting it eight feet long.

For many years, Stefan Bielinski, director of the Colonial Albany Social History Project at the New York State Museum, had compiled and interpreted thousands of eighteenth-century city records. With his help, and by carefully examining period maps and early nineteenth-century drawings and paintings of Albany, I was able to establish the appearance of some of the buildings near the riverfront. The remaining structures were based on general descriptions of the area and assessed tax values. I made assumptions about the configuration and condition of undocumented buildings based on the size and shape of lots and the amount of taxes paid.

It is impossible for an artist to accurately portray something as complex as a city of another era with no references. In such cases I always build scale models. I began this one by basing my layout on a 1770 map of Albany,

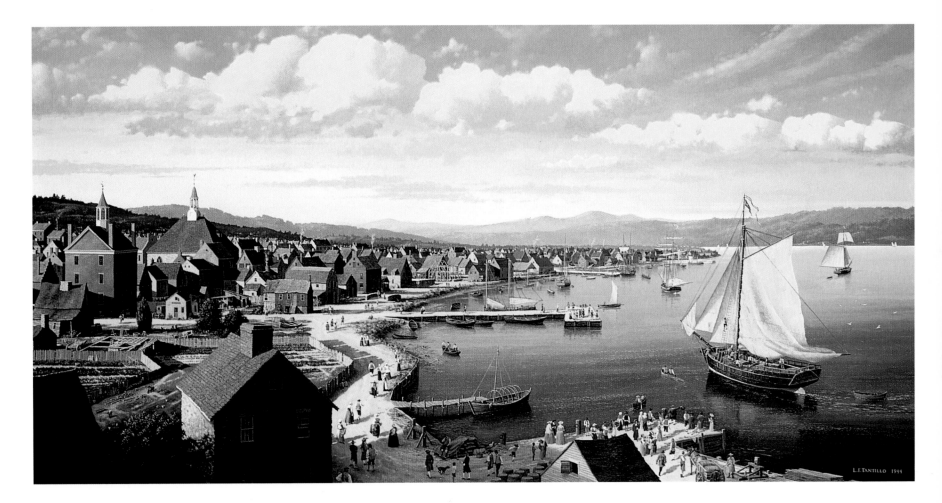

*The Return of the Experiment*

Acrylic on canvas, 48 x 96 in.
Signed and dated lower right:
    L.F. Tantillo, 1994

COLLECTION
KeyBank

which clearly indicated the location and arrangement of major structures. Utilizing my earlier research, I first built models of the well-known buildings, which included the Dutch church and City Hall. They were followed by dozens of houses, barns, and outbuildings. I also modeled the *Experiment* and other river craft. The scale of the layout needed to be large enough to produce relatively sharp photographs. Consequently, the model grew to over twenty feet in length. My friend Mickey Conlee generously donated some of his warehouse space, giving me the room that I needed to work. It took about five weeks to complete the model.

Once I had a way to study the old city, I started making sketches. After much consideration, I decided to place the viewer south of City Hall, at about rooftop height, looking north up the Hudson River. This position placed the *Experiment* in the lower right foreground of the painting, moving away from the viewer toward City Hall Dock. The canvas was twice as long as it was high, allowing me to paint the scene as a panoramic cityscape.

To create the atmosphere of celebration, a large crowd of enthusiastic citizens along Dock Street was needed. Realistically depicting a crowd in a large-scale painting requires special attention. No two people are exactly alike. There are infinite differences in body language, clothing, size, and shape. I needed a large group of real people in colonial costumes, in a festive mood—so my wife and I hosted a picnic in our backyard, to which all our invited guests were asked to wear eighteenth-century clothes. The variety was exactly what I had hoped for, and with only minor alterations with the paintbrush I had what I needed.

Guests at our costume picnic wore period clothing. At right in the photograph above is Dorothy Anson, a very talented seamstress who created many of the authentic outfits depicted in the final painting.

The crew of the *Experiment* is listed, with the amount of pay each man received for the China voyage, in this document from the ship's papers at the New York Historical Society. It is interesting to note that the two cabin boys, one African and the other Dutch, were paid an identical wage.

Excerpt from a New York City newspaper article that appeared a few days after Dean's arrival there on April 20, 1787. (An "s" looks like an "f" in this eighteenth-century typeface.)

APRIL 24.

The sloop Experiment, commanded by Capt. Stewart Dean, arrived at this port on Sunday last, from Canton, in China, after a passage of four months and twelve days. This vessel sailed from hence on the 18th of December, 1785, and was the second adventurer from the United States of America to so distant a port. It was matter of surprise to the natives, and Europeans in that quarter, to see so small a vessel arrive from a clime so remote from China; and must have given them an exalted conception of the exterprizing spirit of the citizens of the United States. The successful and safe return of Captain Dean, has taught us, that fancy oft times paints danger in much higher colours than is found really to exist, and that by maintaining a spirit of enterprize, diligence and activity, we are unable to surmount difficulties, which on a curfory view, are deemed fraught with dangers.—Captain Dean brought home all the hands he took out with him, having had no sickness on board.

This detail from the center of the painting shows two of Albany's most important buildings. The larger structure to the left is City Hall, where, in the mid-1750s, Benjamin Franklin first delivered his papers outlining a plan to unite the colonies. The equally impressive building next to it is the First Church, a major landmark in the city dating back to the early days of the Dutch. The church was located in the middle of the intersection of State and Market streets (Broadway).

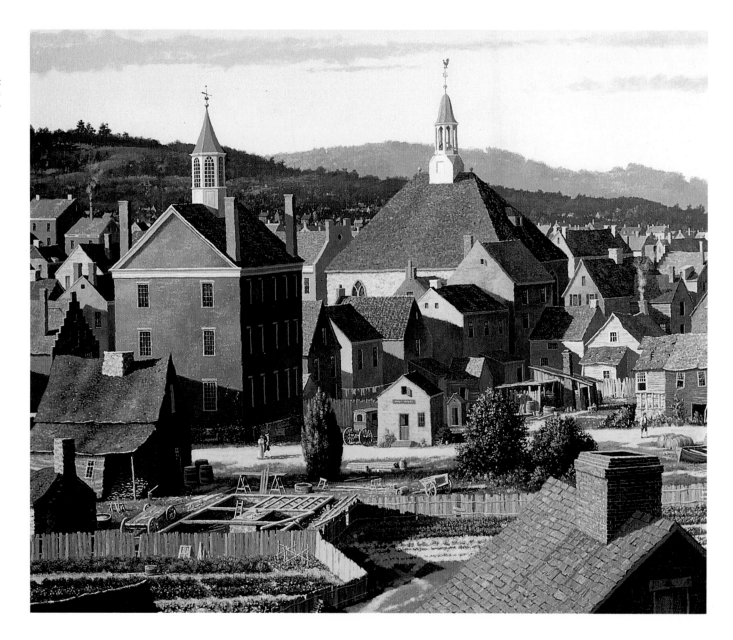

*The Return of the Experiment* was completed after a full year of work. The likelihood that Dean's return to Albany actually looked anything like the scene depicted in my painting is small. For all we know, he could have arrived in the middle of the night or during a storm or even at a different time of year. I do believe, however, that the Albany I painted is close to what existed at that time, and that if Captain Dean had sailed up to City Hall Dock on a sunny late afternoon in June 1787, this is what we would have seen from our rooftop perch.

The center of the painting shows the crowd that has assembled to welcome Dean and his men back to his home port.

In this detail, the *Experiment* is preparing to land at City Hall Dock. The crew is lowering the mainsail and using the jibs to maintain some forward momentum.

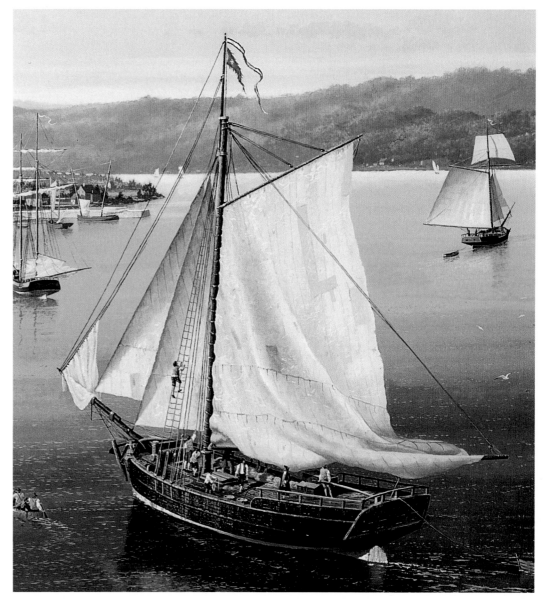

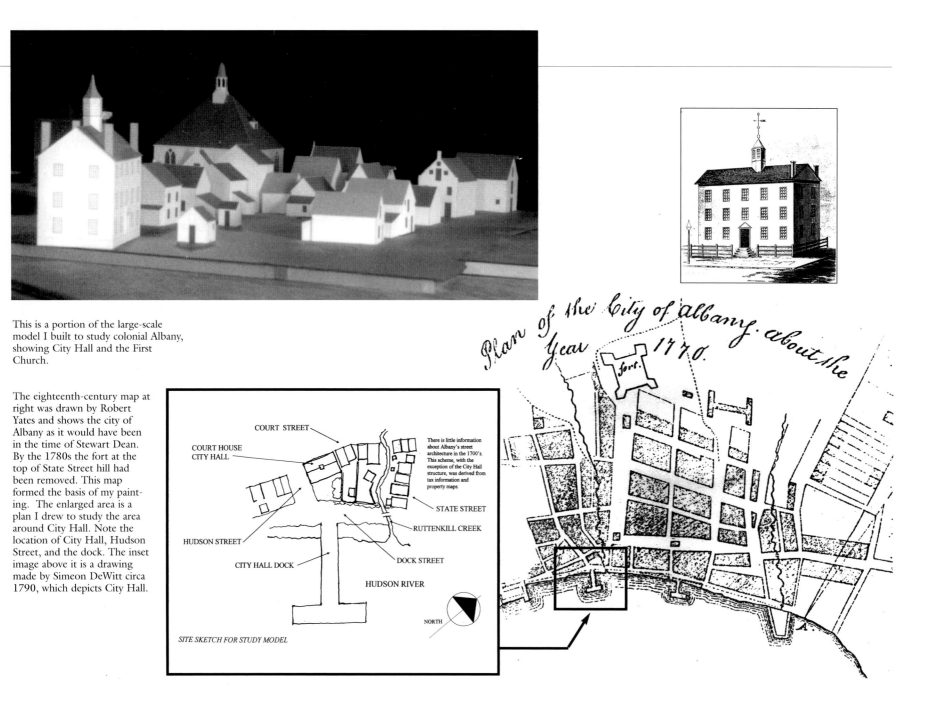

This is a portion of the large-scale model I built to study colonial Albany, showing City Hall and the First Church.

The eighteenth-century map at right was drawn by Robert Yates and shows the city of Albany as it would have been in the time of Stewart Dean. By the 1780s the fort at the top of State Street hill had been removed. This map formed the basis of my painting. The enlarged area is a plan I drew to study the area around City Hall. Note the location of City Hall, Hudson Street, and the dock. The inset image above it is a drawing made by Simeon DeWitt circa 1790, which depicts City Hall.

COURT STREET

COURT HOUSE
CITY HALL

There is little information about Albany's street architecture in the 1700's. This scheme, with the exception of the City Hall structure, was derived from tax information and property maps.

STATE STREET

RUTTENKILL CREEK

HUDSON STREET

DOCK STREET

CITY HALL DOCK

HUDSON RIVER

NORTH

SITE SKETCH FOR STUDY MODEL

Plan of the City of Albany about the Year 1770.

fort.

E

A.

# Outbound Cargo

*(from New York)*

128 barrels of tar, turpentine, rosin, and varnish

4 casks of best Scotch snuff

6 casks of tobacco

4 hogsheads of Jamaica spirits

4 quarter-casks of Madeira wine

50 boxes and 15 casks of Ginseng

1 cask of furs (squirrel, mink, fox, wildcat, martin, bear, raccoon, muskrat, deer)

18 boxes of Spanish silver dollars (1,000 coins equivalent to $22,150 in New York currency at that time)

# Inbound Cargo

*(from China)*

300 chests of Hyson tea

8 chests of highest quality Hyson tea

100 chests of Souchong tea

26 chests of China tea cups and saucers

5 chests of breakfast china

80 bales of Nankeens (silk)

The "General Account & Final Settlement of the Sloop *Experiment*" indicates that the voyage returned profits of only about eight percent. Historians, however, believe that the true profits of this venture were substantially higher.

L.F.T.

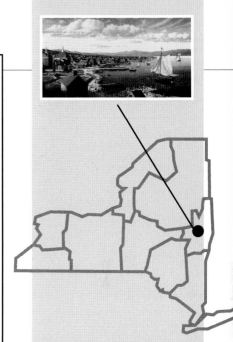

THE SETTING:
This painting depicts the river-front of Albany in June 1787. Albany was also the site of the construction of the sloop *Experiment*.

# Quay Street

In 1813 the United States was still a new country. Westward expansion in New York State was attracting ever-increasing numbers of settlers. The flow of hopeful immigrants traveled up the Hudson River to Albany, on to Schenectady, and then to the west into the Mohawk Valley and beyond. The city of Albany was a hub, and it was growing.

Sometime around 1790, the first major alteration of the Albany riverfront took place. Before that time, various dock arrangements had been implemented, with varying degrees of success. Winter ice and spring floods caused serious damage, making repairs a continuous necessity. Most of the shoreline in front of the city remained unchanged. Besides the forces of nature, there were other reasons for improvement, which included increased traffic and a demand for more warehouse space and more room for loading a rapidly growing number of cargo vessels.

Albany had three primary structures that projected approximately 75 to 100 feet out into the river, dating from around 1770 to 1790. Two of them were docks, and the third appears to be a stone jetty. The jetty structure was upriver from the docks and may have served as an ice deflector and pier. About 1790 a sea wall was constructed that connected the ends of the two docks and continued southward to meet the shoreline. The area enclosed by the sea wall was then infilled with dirt, creating thousands of square feet of new riverfront property with direct access to deeper water and more dock space. The land along the river edge of the infill, adjacent to the sea wall, became Quay Street.

My painting of *Quay Street* is set in 1813 because that period marks the end of Albany as a frontier rivertown. The age of sail was about to give way to steam power, and the Erie Canal would soon accelerate the interior development of New York State. The pace of life was about to quicken.

The painting depicts a quiet riverfront. The workday is winding down as a bright moon illuminates a mackerel sky, its silvery light reflecting off a calm Hudson River. A group of merchants, relaxing after loading a wagon, discuss the day's events. Warm ribbons of lantern light catch the rounded cobblestones of the street. The sturdy sloops creak in the gentle breeze. A solitary crewman aboard a topsail schooner anchored in deeper water makes his final rounds, lantern in hand, before coming ashore. Evening has long been an artistic metaphor for endings, and I wanted my work to symbolize the end of the colonial years in what was to become a bustling industrial age.

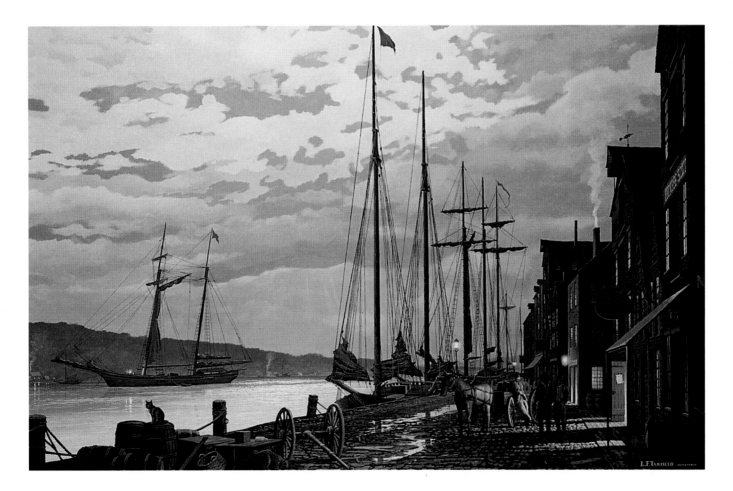

**Quay Street**

Acrylic on canvas, 24 x 36 in.
Signed and dated lower right:
  L.F. Tantillo, 1987

COLLECTION
Patrick and Mary Ann Mahoney

After building a simple study model, I made several pencil sketches to study the layout for this painting. The one I chose to paint appears in panel *A*. The following panels show the progressive development of the painting from the underpainting in *B* to a view of the canvas in *D*, which was 80 percent complete.

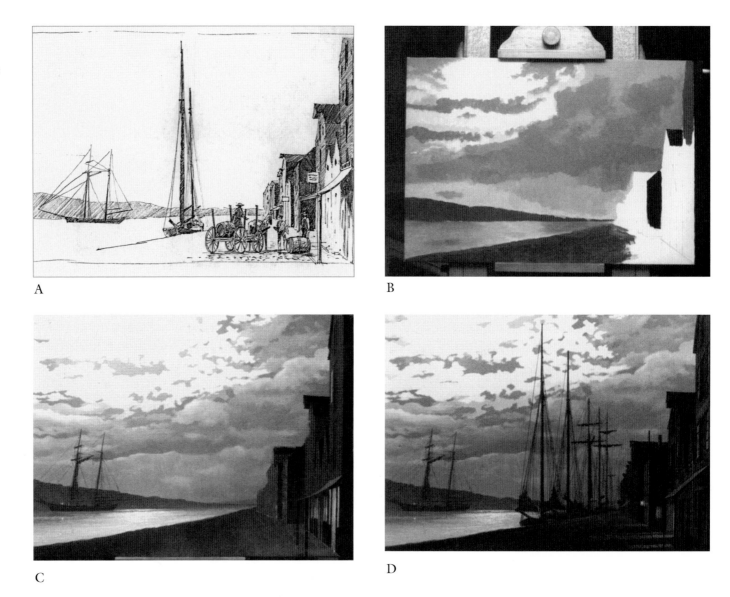

A

B

C

D

THE SETTING:
Quay Street in Albany was built circa 1790 by filling in an area along the Hudson River. For about thirty years this street formed the city's riverfront edge.

L.F. Tantillo, *Quay Street Study* [1992] (David and Barbara Van Nortwick)

# Schenectady Harbor, 1814

Model of a Mohawk River bateau constructed by Phil Lord

his little painting presented some interesting and challenging problems. Graphic information about the area that dates from the eighteenth century is scarce. A tremendous fire in 1819 destroyed most of this section of the city, making all later illustrations and photographs mostly useless for my purposes. Finding a place to begin a project like this requires an open mind, some patience, and a little luck. My client, Karen Engelke, was very interested in participating in the background research. We started by studying street maps from the early 1800s. They provided the general configuration of building lots along the Binnekill Creek and the surrounding blocks. We also obtained property tax maps, which gave the owners' names for the lots. The real key ironically turned out to be the great fire itself.

A local newspaper called the *Cabinet* printed a story on November 24, 1819, entitled "Destructive Fire." The journalist who covered the fire described in detail the damage that occurred to each lot. He gave the name of the property owner, the street location, and the type of structures lost. Taverns, dwellings, barns, stores, outhouses, and sheds were all listed. From that article I knew how many buildings in my subject area existed before the fire. It was impossible to determine the appearance of those structures, but by using generic building types from the period I was able to create a credible density and texture for the Schenectady waterfront.

The foreground focal point of my painting was a far easier task. The New York State Museum, with project director Philip Lord and construction manager John Anson, had just completed a full-size sailing replica of a Mohawk river bateau. Before the building of the Erie Canal, these durable thirty-foot boats carried the bulk of the passengers and freight out of Schenectady and into the state's western frontier. My entire research effort consisted of simply showing up on launch day and photographing the vessel in the Binnekill when the crew raised its sail.

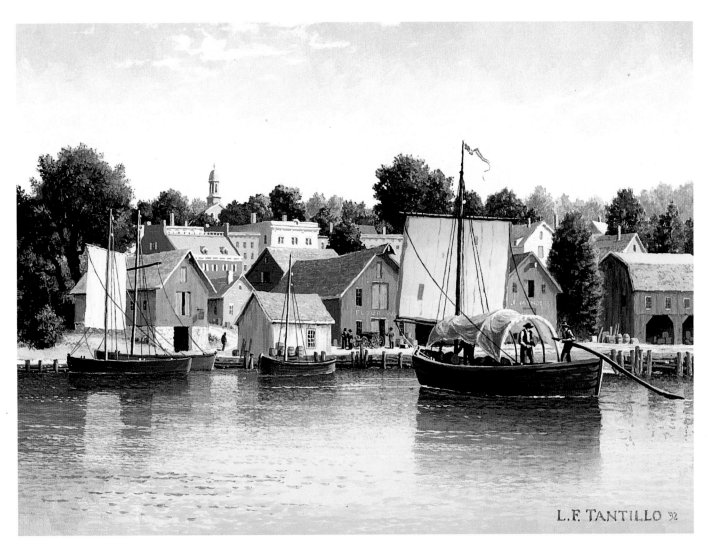

**Schenectady Harbor, 1814**

Acrylic on canvas, 9 x 12 in.
Signed and dated lower right:
  L.F. Tantillo, 1992

COLLECTION
Karen Engelke

# Schenectady and the Inland Waterway

**Philip Lord, Jr.**

The natural harbor that existed in the mouth of the Binnekill made Schenectady the point of embarkation for boats to the western frontier throughout the eighteenth century. From this place innumerable bateauxmen pushed and poled their craft up the Mohawk to the head of navigation at Fort Stanwix. Surmounting the nearly one hundred rapids and rifts that stood in the way, many of them less than knee-deep, took several days. Boats leaving this landing often went beyond the Mohawk, passing down Wood Creek, Oneida Lake, and the "Onondaga" to Oswego and the Great Lakes.

But it was late in its one-hundred-year history that this harbor grew to be a principal inland port of the new American republic. It waited for the completion of the navigation improvements of General Schuyler's Western Inland Lock Navigation Company in 1798, creating a continuous waterway connecting Schenectady to Oneida Lake.

The closing hours of the eighteenth century saw the emergence of a new commercial fleet. Great Durham boats, carrying many times the cargo of the smaller bateaux and too large to be portaged around obstacles in the river, opened a new era of transportation along the Mohawk-Oneida waterway. As settlement in the west increased and the profitability of expanding markets attracted merchants to the upstate region, warehouses sprang up on the banks of the Binnekill, at Canajoharie, Little Falls, Utica, Rome, Oswego, Ogdensburg, Kingston, and points west.

For two glorious decades, before being brought to its knees by the disastrous fire of 1819, the Schenectady waterfront served as the gateway to the American West. Its warehouses held the richness of the world for shipment to the emerging western settlements and received the produce of the land in exchange.

Barely recovering from the fire, the once-thriving port was in the end abandoned in 1823, as the new Erie Canal passed through the city on an alignment far to the south. This historic waterfront, witness to the ebb and flow of historic migrations, the hurried urgency of war, and the wealth of commerce, slowly drifted into history, the ghost and sentinel of a magnificent past.

*Philip Lord, Jr., is Chief of History at the New York State Museum, Albany, and an inland navigation history specialist.*

I took this photograph on the day of the launching of the bateau replica, *Discovery*. The craft was built by the New York State Museum and used as part of an educational program to present the history of the Mohawk River. Craft of this type were designed to be poled, sailed, or rowed, depending on river conditions.

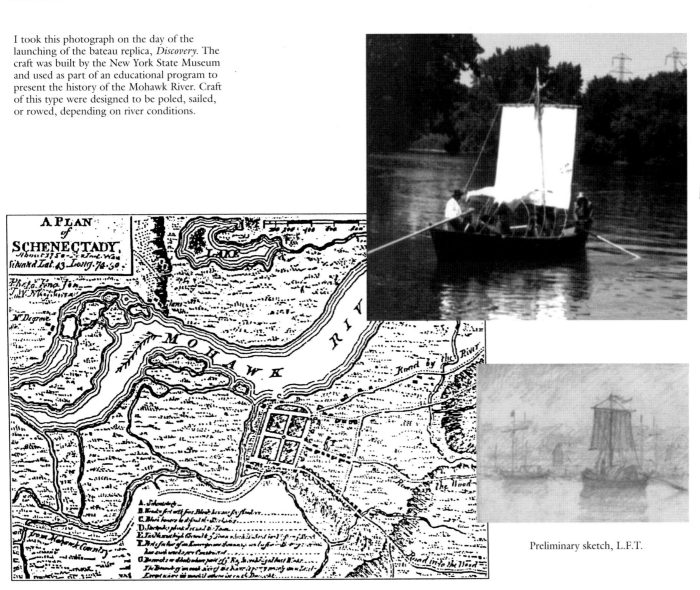

A PLAN of SCHENECTADY

Map of Schenectady, dated 1750

Preliminary sketch, L.F.T.

THE SETTING:
Schenectady Harbor was located along the Binnekill Creek adjacent to the "stockade" section of the city of Schenectady. The Binnekill flows a short distance north and intersects the Mohawk River.

he Erie Canal opened the door for westward expansion and the development of New York State. By the 1840s, grain from the Midwest was arriving by the ton in Buffalo, where it was transferred to barges and shipped off to the markets of New York City via the canal. Until that time grain ships were unloaded by hand, using Irish immigrant labor and wheelbarrows. In 1842, Joseph Dart invented the world's first grain elevator. He constructed a huge barn and adapted a steampowered conveyor belt that could be operated vertically. In one operation, tons of grain could be lifted from a ship's hold into wooden storage silos. When the time came to load canal barges, he merely reversed the process. His neighbors ridiculed him. The comment most often heard was, "Why build such a frivolous machine when the backs of the Irish are so cheap!" However, in a very short time, Dart's elevator proved to be an outstanding financial success. The idea caught on, and Buffalo Harbor soon was

Joseph Dart

crowded with dozens of grain elevators. Within a few years similar structures appeared in harbors around the country and in foreign ports.

Understanding the significance of Joseph Dart's invention and picturing it nearly 135 years after its demolition are two entirely different endeavors. In this case the problem of the latter was made much easier because of the foresight of an obscure itinerant draftsman named Edwin Whitefield. Historians owe a great debt of gratitude to a handful of American artists who traveled the countryside with pen and paper, documenting early nineteenth-century cities. Their work was not popular at the time. Galleries and collectors primarily were interested in the magnificent works of the Romantic landscape painters. In an age before photography, the outstanding pen-and-ink drawing of Edwin Whitefield captured what the 1840 Buffalo waterfront and Dart's original grain elevator looked like. That drawing became the basis for my painting.

Whitefield's view, which was taken from the top of the old lighthouse, looks across the creek to the northeast at the city of Buffalo. The angle I wanted to paint was a water-level view looking northwest, directly at Dart's elevator. The problem became how to translate the contemporary drawing into a form I could study from a different vantage point. Computer models are difficult to build and do not provide a tactile three-dimensional experi-

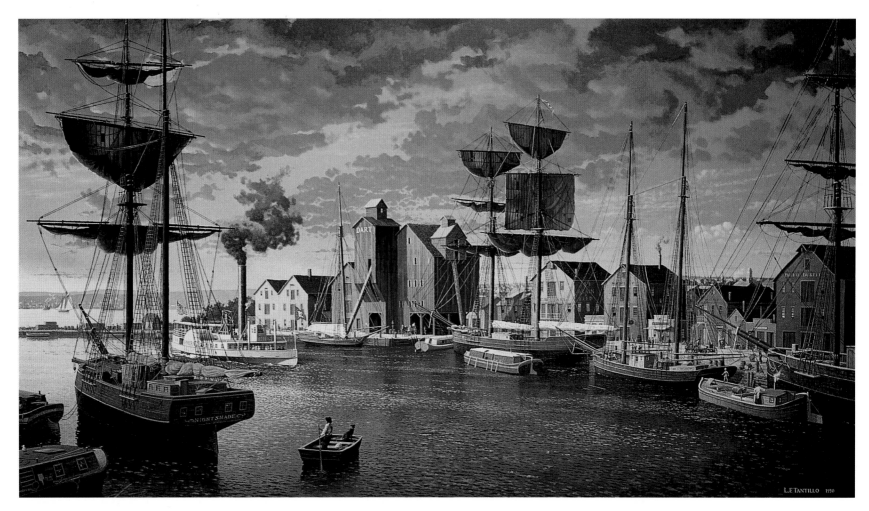

***Buffalo Harbor, 1847***

Acrylic on canvas, 40 x 70 in.
Signed and dated lower right:
   L.F. Tantillo, 1990

COLLECTION
KeyBank

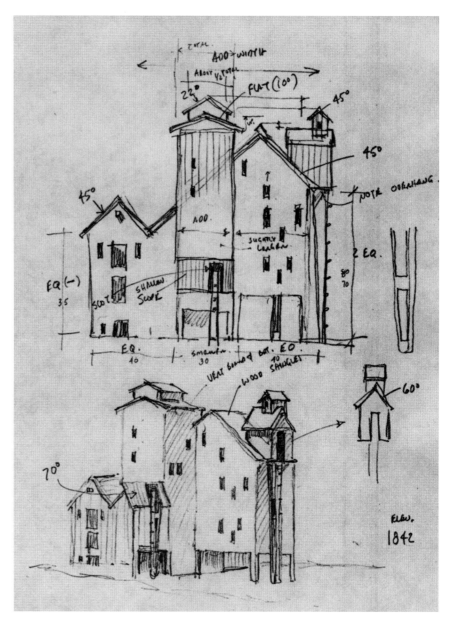

The detail above is from a larger drawing done in the 1840s by Edwin Whitefield. The artist had positioned himself in the tower of a lighthouse directly across Buffalo Creek to make this extremely accurate view of the city of Buffalo. The Dart grain elevator is clearly visible at the entrance to the Erie Canal feeder. I used the Whitefield drawing as a guide for the buildings in my painting. To the right is my pencil study of the Dart elevator, with dimensions and notes.

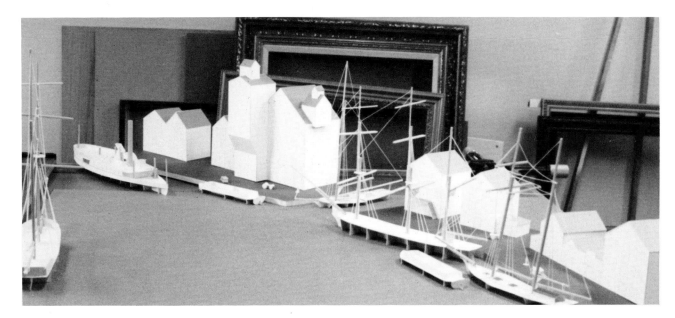

This is my study model of Buffalo Harbor. It is not necessary to complete these models in any great detail because they serve only to establish relative proportions.

THE SETTING:
The Buffalo Harbor view depicted in the painting is located near the entrance to Buffalo Creek. The site is used today as a naval park and features a display of warships from World War II.

ence. I proceeded to construct a simple large-scale architectural model, using the building facades that were distinctly rendered in the Whitefield drawing. Individual building plans were derived from property maps of the period. I also researched and developed simple models for numerous Great Lakes vessels. The busy harbor would need barks, brigantines, schooners, sloops, barges, and small rowing craft. I also included the small passenger steamboat *Emerald*, which can be seen in Whitefield's drawing.

As I peered along the white cardboard-and-paper model, with all the ships in place, letting my imagination create walls of brick and clapboard, I was transported back through time. That experience gave me the confidence to paint the scene.

# Steamboat Square

Study model of the steamboat *Alida*, L.F.T.

Steamboat Square was the busiest hub of passenger activity on the upper Hudson River. By the mid-1800s, as new territories opened up to the west, many thousands of travelers passed through the portals of Albany. Some stayed, and some moved on. Irish immigrants, who had fled dismal conditions in their homeland, streamed northward aboard steamboats, schooners, and sloops to the promise of a better future. Albany was just completing the majestic Cathedral of the Immaculate Conception, which dominated its skyline. Passengers bound for points west could depart directly from Steamboat Square via several railway lines or Erie Canal packet boats.

Albany was coming of age, and its passenger steamboat landing showed all the trappings of an up-to-date, active urban space. Adjoining the warehouses that crowded the square were numerous hotels and the city's finest restaurants. One newspaper even warned visitors to "beware of vagabonds and pickpockets."

In researching this work I consulted various picture archives. Photographs and drawings from the collection of the Albany Institute of History and Art were particularly helpful in determining architectural character and detail. Additionally, I had painted this part of the city before and was familiar with many of the structures. The background buildings, which are important in establishing a setting, are only a small part of the story this work tells. The essence of this project was not so much the look of the city but the overall design and atmosphere of the painting.

The steamboat *Alida* was the most difficult challenge. I wanted a foreground element that would lead the viewer's eye toward the landing pavilion. The most obvious choice was a passenger vessel of some distinction. By all historical accounts, *Alida* was a frequent sight at Albany in those days. Although the beautiful steamboat had

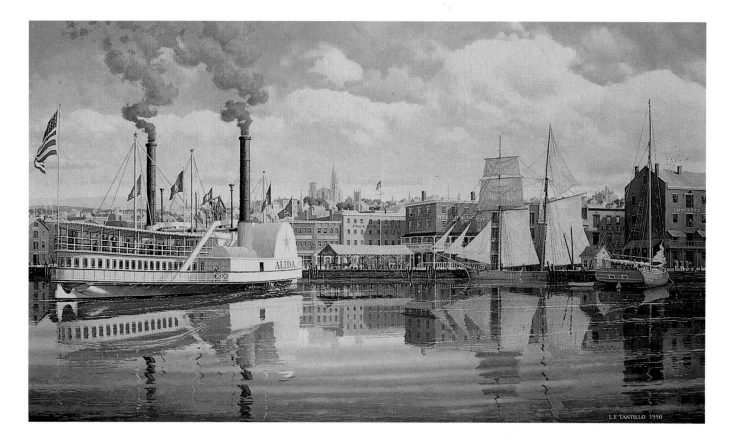

**Steamboat Square**

Acrylic on canvas, 28 x 48 in.
Signed and dated lower right:
  L.F. Tantillo, 1990

COLLECTION
Francis H. Trombly, Jr.

never been photographed, several highly detailed sideview paintings by James Bard and Currier & Ives were available.

Subjects of this type are extremely complex. The decks are curved both vertically and horizontally. Additional curvilinear surfaces make up the paddleboxes, boilers, stacks, and deckhouses. Compounding the difficulty is the fact that the steamboats no longer exist; their lines are unfamiliar to us in the late twentieth century. Getting the *Alida* right was essential to the credibility of my painting.

Using the period paintings as reference and applying cross-sectional specifications and elevations, I was able to construct a basic model of the ship. Once completed, the model enabled me to study the craft from a number of slightly varying angles and select just the right one for my painting.

The fundamental design of the work has an overall simplicity consisting of three horizontal bands: the sky, the city, and the water. However, if you look closely at the water you will notice that it is very still and calm. There are barely a few ripples. Still water has the reflective qualities of a mirror and, as such, required the careful painting of an inverted image of the subject. This is a much more complicated task than it appears, and the reward for the effort is an effect the viewer perceives only subtly. The reflection enhances the depth of the image and emphasizes the lines of the steamboat, while at the same time establishing the calm and peaceful atmosphere of early morning.

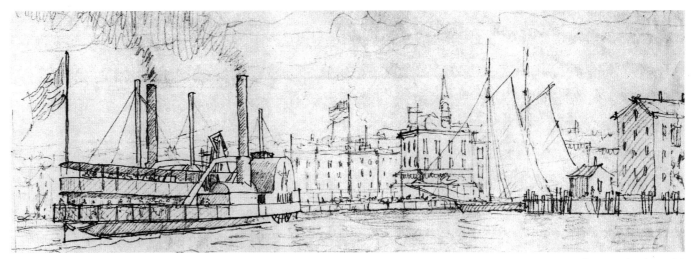

Preliminary sketch, L.F.T.

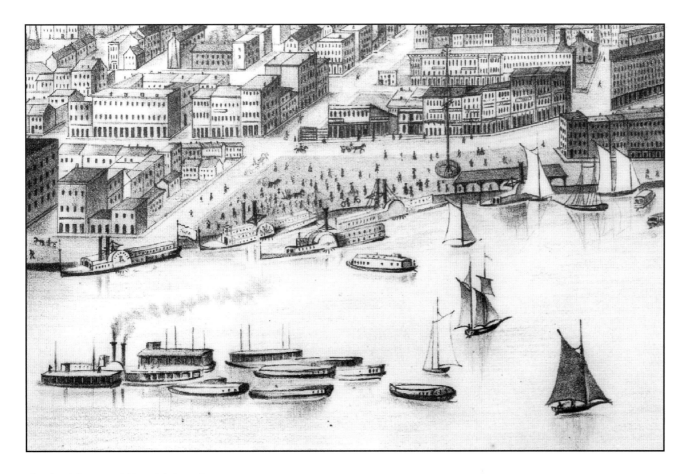

Steamboat Square was the major hub of passenger traffic in mid-nineteenth century Albany. The site was along the riverfront just south of the Dunn Memorial Bridge.

This detail from an 1850s aerial view of Albany, New York clearly shows the area in and around Steamboat Square. Several versions of this drawing exist, each including slightly different elements. It is interesting to note the variety of rivercraft depicted. In addition to the passenger steamboats, there are sloops and schooners, towboats and barges. Drawings like this are helpful in depicting background buildings.

# The City of Albany, New York

he industrial revolution was under way, and American port cities were bustling with activity. The capital district of New York State was no exception. With the end of the Civil War came a new vigor. The Hudson River was busier than ever. The Albany Basin was the upstate hub of marine commerce. Heavily laden schooners and steamboats transferred goods through the basin bound for the inland ports of the Great Lakes and the cities of western New York via the Erie Canal. Coming from the other direction, eastbound goods such as salt and grain arrived on an almost daily basis. Numerous grain elevators were used to store these goods to await better prices or further shipment arrangements. Structures of brick and wood crowded every available foot of riverfront property as vessels of steam and sail maneuvered in and out of port. Albany was experiencing the prosperity that the War between the States had brought to many northern cities.

*The City of Albany, New York* was my first major historical painting. When I began the work I had no idea how challenging it would be to produce. There are nearly 300 buildings depicted, many of them in intricate detail. The entire project required hundred of hours of work and spanned seven months.

The lengthy research phase consisted of gathering and cataloging hundreds of historical photographs from the Morris Gerber and Albany Institute of History and Art collections. I then did numerous pencil drawings in progressively larger scales. The final layout was actually produced in stages, as a series of overlays on tracing paper. I painted the sky first. The city was next. I worked from right to left. Each five- to six-hour painting session consisted of transferring a three-inch square section of cityscape to the canvas and then painting it from start to finish. I often have thought that time-lapse photography of this process would have been very interesting; unfortunately this idea occurred to me long after completion of the painting.

Once the city was finished, I began the foreground. I had the honor of working with one of the most distinguished and knowledgeable Hudson River steamboat his-

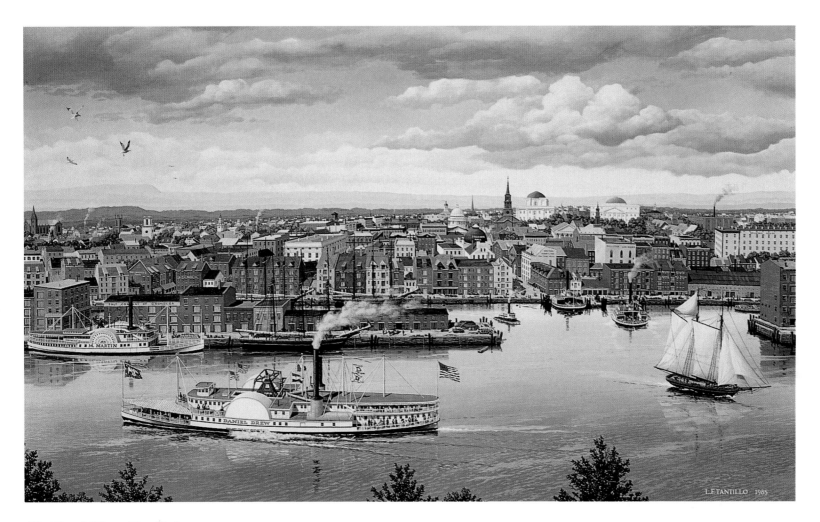

*The City of Albany, New York*

Acrylic on canvas, 40 x 60 in.
Signed and dated lower right:
    L.F. Tantillo, 1985

COLLECTION
Michael B. Picotte

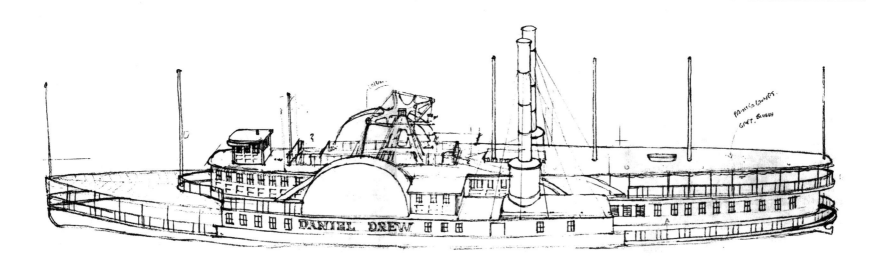

The late Donald Ringwald spent his life studying and documenting the vessels of the Hudson River. His numerous books are a lasting tribute to his great knowledge. I had only one opportunity to work with Don. This painting of the city of Albany was my first New York State historical work, and I wanted to get it right. With his help I made numerous sketches of the steamboats I would be using in my image. The drawing of the *Daniel Drew* (above) was the result of one of our collaborations.

torians, Donald Ringwald. His books, which document the great vessels that plied New York State's magnificent river, are still the definitive reference resource on the subject. With his help, I was able to select and accurately depict a credible variety of rivercraft, including the impressive side-wheeled steamboat, the *Daniel Drew*.

One of the most interesting stories I came across on this project dealt with Abraham Lincoln's visit to Albany in 1861. The president and his entourage were lodged at Albany's largest and most famous hotel, the Delavan House, located on Broadway, a few blocks north of State Street. On February 8, 1861, President Lincoln passed

down Broadway on his way to address the state legislature on Capitol Hill. In a small hotel room two blocks away, overlooking the presidential parade, sat John Wilkes Booth. The actor was in Albany to perform in a Shakespearean play and was staying at the Stanwix hotel. Years later, there was speculation that Booth actually may have been stalking Lincoln in Albany. In the painting, the Delavan House is the large, light-colored building on the extreme right edge; Stanwix Hall is the dark-domed building near the middle of the image, with its name lettered on the dome.

Tweedle Hall, Albany, circa 1862.

In order to come up with the details necessary to create a credible aerial view of the city, I examined hundreds of period photographs. The Morris Gerber Collection was extremely helpful, as was the Albany Institute of History and Art photo archive. Even with these great resources, some speculation was still necessary.

THE SETTING:
Albany was a thriving American city in the 1860s. As happened in so many other industial areas in the North, the Civil War brought prosperity, expansion, and development.

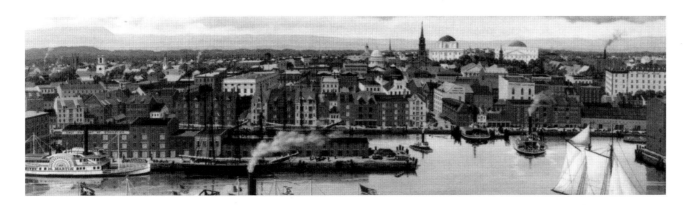

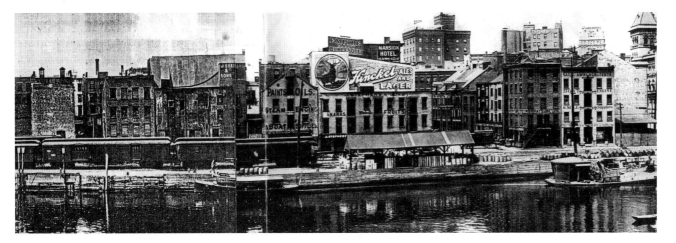

# Union Depot, 1879

Railroads dominated the American economy in the nineteenth century. The New York Central & Hudson River Railroad had by the late 1800s established itself as one of the leaders in the industry. Reflecting its great success, magnificent structures were erected to serve its passengers. In 1872, Union Depot was completed in Albany, New York. The building was an excellent example of Second Empire Victorian architecture and borrowed several of its features from New York City's Grand Central Station (1871) and Chicago's Passenger Depot (1871). Yet changing times, a

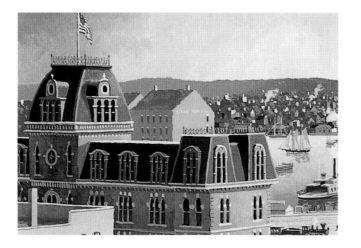

L.F. Tantillo, *Union Depot (color study #1)* [1992] (Lois and Stewart Wagner).

poor location, and the need for more space surprisingly soon led to the construction of a new Albany railroad terminal. Union Depot was demolished in 1899, after only twenty-seven years of service.

In the painting the viewer is a few hundred feet off-shore, looking back across a very busy waterfront. Directly behind the tugboat *Carrie* is the modest passenger station of the Delaware & Hudson Railroad. Continuing to the left along Quay Street is the ferry house of the Troy & Albany Steamboat Company, followed by the iron railroad bridge. Overlooking the entire area and rising majestically above the stone retaining wall is Union Depot, the Stars and Stripes waving proudly atop its mansard tower.

This subject had interested me for some time, because it had so many great elements— wonderful architecture, dynamic maritime features, and a site that stepped up in distinct levels from the water. The problem became one of choosing a point of view. Numerous preliminary sketches were done. I still could not decide, so I painted several color studies from the most promising angles. They all seemed to possess equally interesting attributes. Together, my client and I discussed the features of each one and finally selected the water-level view, which I painted.

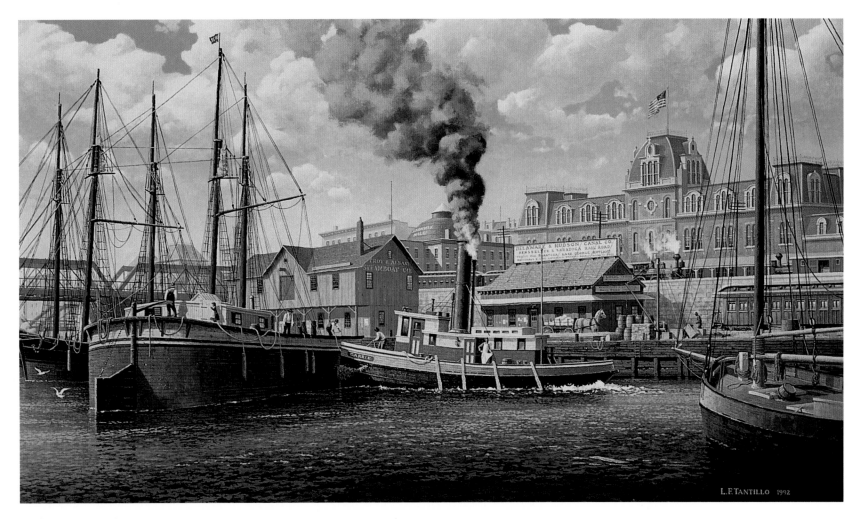

***Union Depot, 1879***

Acrylic on panel, 24 x 40 in.
Signed and dated lower right:
    L.F. Tantillo, 1992

COLLECTION
Lois and Stewart Wagner

The pencil sketch (*right*) was one of several I did to study the stern of the canal barge in the foreground of this painting. The photograph (*far right*) shows the roof of the Delaware & Hudson Depot along Quay Street immediately below Union Depot. Note the numerous signs and roof braces.

The towing ticket from the steamboat *Carrie* indicates that the vessel was kept at the corner of Columbia and Quay streets in the Albany Basin. Captain J.D. Ostrom was paid $2.00 in cash on November 13, 1870, for local service. I was never able to find any image of the actual craft but the 1870s-vintage tug in my painting bears a very real signboard.

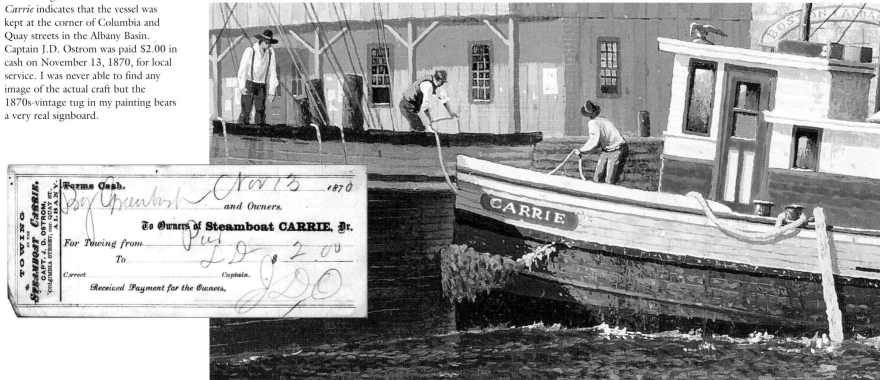

Union Depot was located on the northeast corner of Montgomery Street and Maiden Lane in Albany. The east side of the building faced the railyard and the Hudson River.

Photographs of Union Depot are extremely rare. This view was taken from an upper-floor hotel room in Stanwix Hall and was used in a series of local images on stereopticon cards. We are looking north on the very narrow Montgomery Street. In addition to the numerous and notable Victorian details, this station, like so many other public facilities of that time, had separate waiting rooms for men and women.

*Union Depot, 1879* ❧ *93*

# Engine 999

ngine 999 was the fastest machine on earth in May 1893. In my painting, the famous locomotive is on a westbound run. The engine is pulling the Empire State Express and has stopped at the Batavia passenger station of the New York Central & Hudson River Rail Road, not far from the stretch of track where the record speed of 112.5 miles per hour was set. As a group of passengers look on, a photographer prepares to take some publicity pictures. He explains to the engineer, Charlie Hogan, and his fireman, Al Elliot, exactly how he wants them to pose. The photographer's attentive assistant dutifully removes some accumulated dust from the shiny new engine.

The Batavia railroad yard was home to two passenger depots in the early 1890s. The New York Central & Hudson River Rail Road structure was on one side of the tracks, and the New York Lake Erie & Western Rail Road station was on the other. Directly behind Engine 999, an 1891 Baldwin ten-wheel camelback leaves the station. The gable end and the roof of the Lake Erie & Western depot projects above the camelback's coal tender. In the immediate right foreground is the gable end of the New York Central & Hudson River depot. A sign reading "NY 408" indicates the mileage from Batavia to New York City.

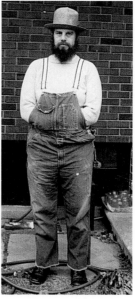

Warren Greatbatch posing as Al Elliot.

L.F.T.

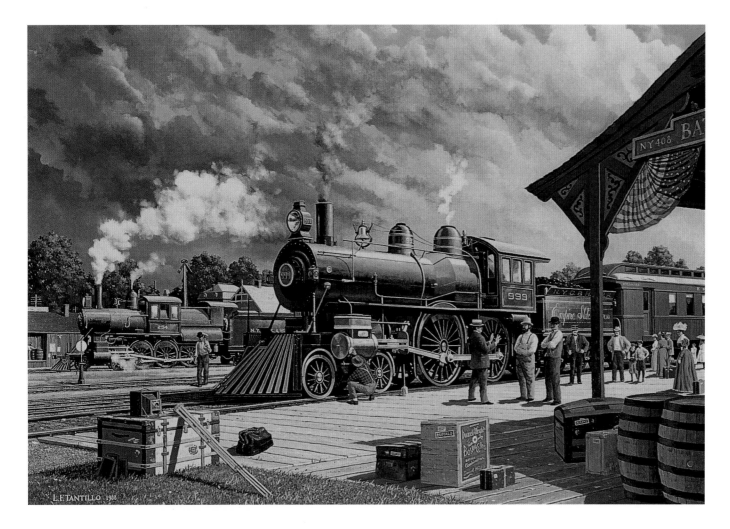

*Engine 999*

Acrylic on panel, 26 x 38 in.
Signed and dated lower right:
  L.F. Tantillo, 1988

COLLECTION
Wilson Greatbatch, Ltd.

# The Pride of the Fleet

## David R. Gould

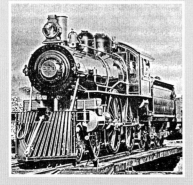

Engine 999

Engine 999 was both a mechanical triumph and a publicity stunt. Even the number was selected for its dramatic impact. The engine was conceived by George H. Daniels, general passenger agent for the New York Central and Hudson River Rail Road, as a promotional device to garner public attention and increase ridership for the upcoming Columbian Exposition. Completed at the company's West Albany shops in April 1893, Engine 999 was assigned to pull the railroad's premium train, the Empire State Express. On May 9, 1893, Engine 999 hit 102 miles per hour, and the next day it set the still debated record speed of 112.5 miles per hour. The engine owed its agility to the sound design concepts of William Buchanan, superintendent of motive power for the railroad, who combined proven mechanical features with huge 86-inch drivers. The result was an engine that could not pull very much but could attain remarkable speeds. Thus, on a perfect May morning, taking advantage of a straight, slight downgrade on carefully ballasted track west of Batavia, near the junction with the New York Lake Erie & Western Rail Road, Engine 999 streaked into the popular imagination. In an era before the automobile and airplane, when railroading dominated the popular media, 999 became the star attraction at the Columbian Exhibition in Chicago, the embodiment of modern speed and power.

Fame was fleeting, however. After 999 was assigned to regular service out of Syracuse, it soon became apparent that the engine would pull better with smaller drivers. Acordingly, 999 was rebuilt in 1899 with more practical 70-inch drivers, and it was assigned to branch-line local and milk trains. Receiving a new boiler in 1906, Engine 999 lost even its number in 1913 and later narrowly avoided scrapping. Refurbished and renumbered in 1923, Engine 999 became a showpiece for the company's centennial and thereafter appeared regularly at railroad and world fairs. Presented to the Chicago Museum of Science and Industry in 1962 and displayed outside, 999 suffered the effects of poor upkeep and thirty Lake Michigan winters. Happily the old engine has recently undergone a careful cosmetic restoration to its earlier showpiece appearance and has been moved indoors. As the centerpiece of a new exhibition, Engine 999 is finally reclaiming a small portion of its earlier fame as the embodiment of high-speed railroading.

*David R. Gould was Supervisor of Exhibit Planning at the New York State Museum, Albany, for twenty years and is a railway history specialist.*

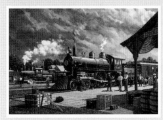

Don Guarino posing as a rail-road maintenance worker, photographed by L.F.T.

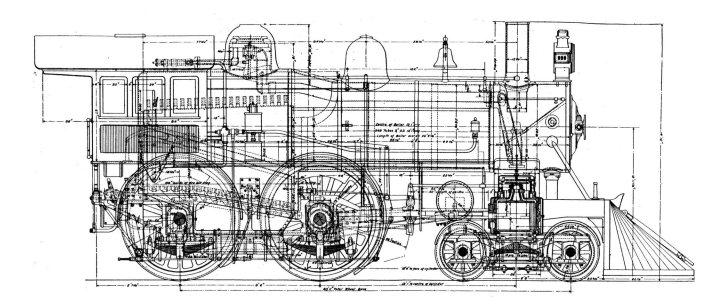

THE SETTING:
The *Engine 999* painting is set in Batavia in May 1893. The appearance of the station and surrounding structures was based on postcards in the Lester Wright collection.

The well-proportioned lines of Engine 999 are illustrated in this dimensional drawing made a few years after the record-setting run. Note the scale of the eight-foot driver wheels in relation to the engine's wooden cab.

# The Mary Powell at Rondout Creek

Of the hundreds of beautiful steamboats that glided up and down the Hudson River from 1807 into the 1960s, one vessel stands above all others. It was not the largest or the fastest. It was built in a time of craftsmanship, at the dawn of the golden age of Victorian design. The title "Queen of the Hudson" was bestowed on the *Mary Powell* before it ever moved under its own steam. To this day that moniker has never been challenged.

The *Mary Powell* was built at Allison's Shipyard in Jersey City, New Jersey, at a cost of about eighty thousand dollars. The five-hour maiden voyage from New York City to Rondout Creek, which empties into the Hudson at Kingston, took place on October 12, 1861. At the time of construction, the ship measured 267 feet in length by 34 feet, 6 inches in breadth. The enormous cylinder of the vertical beam engine was 5 feet, 2 inches in diameter and had a stroke of twelve feet.

The *Mary Powell* was named after Mary Ludlow Powell of Newburgh, New York. She was the widow of the prominent banker and successful steamboat entrepreneur Thomas Powell.

Home port for the *Mary Powell* was Rondout Creek. Most of the steamboat's long and distinguished career was spent operating between Kingston and New York City, with occasional excursions to Albany. It seems that in every one of its early seasons of service the *Mary Powell* was setting records. Throughout fifty-seven years of service on the river and despite many alterations, including the lengthening of the hull by 22 feet, the beauty of this vessel was never diminished.

My painting depicts the *Mary Powell* at Rondout Creek shortly after sunrise in the summer of 1893. Steamboat historians may question the validity of this particular landing point along the bulkhead, since it was not until 1895 that the ship took on passengers from this location for its morning-boat service to New York. Aesthetically this site offered prominent and interesting east-facing building facades, which could be used to

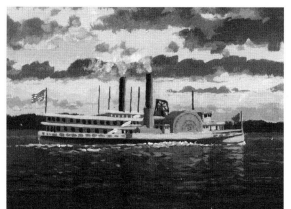

L.F. Tantillo, *Mary Powell in Transit (color study)* [1992] (Wenonah K. Tantillo).

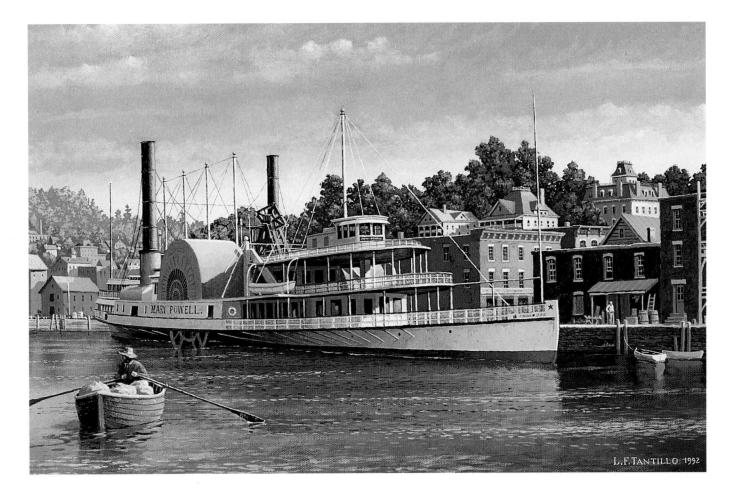

**The Mary Powell at Rondout Creek**

Acrylic on canvas, 11 x 16 in.
Signed and dated lower right:
L.F. Tantillo, 1992

COLLECTION
Richard and Ellen Whipple

THE SETTING:
Rondout Creek flows into the Hudson River at Kingston. From the 1820s to the early 1900s the Rondout provided the primary access to the Delaware & Hudson Canal, which extended across New York state to the coal mines of northeastern Pennsylvania.

I used this 1902 photograph by F.J. Sedgwick to establish the architectural background details for my painting, including the late Victorian houses on the hill-side.

enhance the effect of early morning light. So why is it 1893 and not 1895? I wanted to paint the full curvature of the ship's starboard paddlebox. Alterations in 1894 provided private enclosed parlors on the promenade deck ahead of the paddleboxes, which would have obscured my view. So, we will assume that on this 1893 morning, for one reason or another, the captain decided to try out a new landing. He must have liked it, because it was used for nearly the next twenty years.

The turn of the century saw the emergence of many new steamboats. Soon the ship known as the Queen of the Hudson was being surpassed in speed, size, and elegance by a new generation of steamboats. The 1861 design was obsolete. In 1920, the *Mary Powell* changed hands for the last time when it was sold to John A. Fischer for $3,200. On April 20th of that year it was towed to its final resting place in Rondout Creek. There the Queen was dismantled and her bones left to slowly dissolve into the mud, a sad ending indeed for such an illustrious vessel.

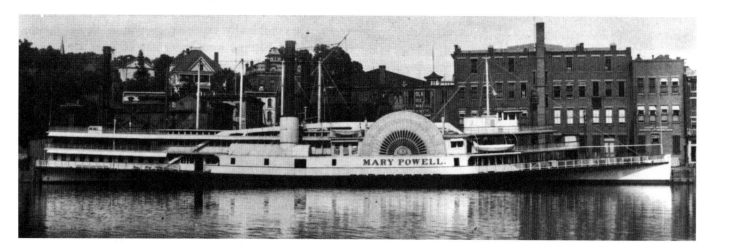

# The Steamboat Era on the Hudson River

**Roger W. Mabie**

L.F. Tantillo, *North River Steam Boat* [1989] (Victor and Lyn Riley).

During the summer of 1989, the Port of Albany sponsored a "Port Fest," in part to highlight the port's importance to the economy of the capital area. Participating in the event, Len Tantillo prepared a poster detailing the wide range of vessels that had been in use on the upper Hudson over a span of nearly four centuries. His superb renderings of eight Hudson River steamboats depicted typical representatives of the colorful period known as the "steamboat era."

At the beginning of the nineteenth century, people could travel only as fast as horses could carry them or pull them in a wheeled vehicle, or as fast as a vessel propelled by the wind. At that time, two men, who were both in Paris, had a keen interest in the possibilities of propelling a vessel by a steam engine. Robert Fulton, studying art, and Robert Livingston, Thomas Jeffer-

son's minister to France, struck up a friendship that culminated—primarily with Fulton's ideas and Livingston's financial backing—on August 17, 1807, when a vessel known as the *North River Steam Boat* left a dock in New York City for an upriver trip to Albany. It was to become the world's first commercially successful steamboat.

Livingston was also a political power in New York State; as a result of the Fulton-Livingston achievement, the state legislature granted them a monopoly for the navigation of vessels propelled by steam on waters in and contiguous to the state. It turned out to be a contentious event and was beset by law suits on the part of would-be competitors.

During a five-year span in the 1820s, three events took place that were to have a major impact on the river's commerce. In 1824, the U.S.

Supreme Court declared the Fulton-Livingston monopoly null and void. In 1825 the Erie Canal opened and, in 1828, the Delaware & Hudson Canal opened to bring coal from northeastern Pennsylvania to the tidewater at Kingston.

The Hudson River–Erie Canal route almost immediately became a major transportation artery to the Midwest. Technological advances in steamboat design and propulsion were rapid, and by the 1830s the running time between New York and Albany had been reduced to nine hours, essentially what it remained into the twentieth century. By the 1840s, two distinct types of steamers had evolved—day boats and night boats. The day boats operated primarily during daylight and generally were smaller, faster, and characterized by more open deck space. The night boats were larger and had one or two tiers, or decks, of

L.F. Tantillo, *Transport* [1989] (Corliss R. Tantillo).

staterooms above the main deck, most of which was used for carrying freight. These latter vessels would leave their point of departure at nightfall and arrive at their destination by daybreak.

The early railroads channeled passengers and freight to the steamboats. Until a railroad from New York City, along the east shore of the Hudson, reached the Albany area in the early 1850s, everything that moved—passengers, freight, and mail—did so, as long as the Hudson was navigable, by steamboat. Competition was keen. Rate wars were common, and during the height of the season the fare for passage would go up and down like the proverbial yo-yo. Among the day boats, racing was frequent—the steamer that arrived at the landing first got the waiting passengers.

The high tide of steamboating on the Hudson probably occurred during the three and a half decades following the Civil War. Every city north of Newburgh, and even some villages such as Saugerties and Catskill, were served by steamboat lines between their communities and New York City. The steamers were large, luxurious by the standards of the day, and profitable. One steamboat in particular, the *Mary Powell*, became the Hudson's best-known steamboat. Called the "Queen of the Hudson" for its speed and beauty, it made a round trip

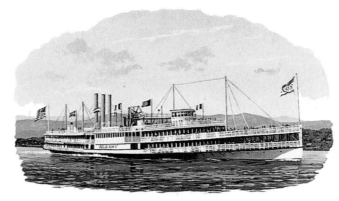

L.F. Tantillo, *Albany* [1989] (Michael and Sharon Fernandes).

every day during the season between Kingston and New York, with way landings, from 1861 until its retirement in 1917.

Another form of commercial steamboat was the ferry boat. Before the advent of bridges spanning the Hudson, ferry boats in great profusion traversed the stream. From lower Manhattan to Albany, there were only short stretches of the river where one could not see a ferry boat steaming from shore to shore. Typical of these maritime workhorses was the *Transport*, a ferry that crossed the Hudson from Kingston to Rhinecliff from August 1881 until September 1938.

The city of New York at the river's mouth, with its exponential rate of growth, had a voracious appetite during the post–Civil War years for the products of Hudson

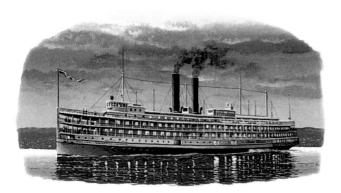

L.F. Tantillo, *Fort Orange* [1989]
(Michael B. Picotte).

River-related industries. Included in this category were brick, natural ice, Rosendale cement, Ulster County bluestone for curbs and sidewalks, Pennsylvania coal via the D&H Canal, baled hay for the thousands of horses then on the city streets, and agricultural products. The agricultural products moved overnight by steamboat. The rest, because of their weight and bulk, moved by barges and scows in large armadas pulled by towboats such as the *Norwich*. This venerable steamboat had the longest life of any Hudson River steamer. Built originally in 1836 as a passenger vessel for service on Long Island Sound, it came to the Hudson River in 1843. After losing its appeal to the traveling public, it was converted to a towboat about 1850 and served in this capacity until 1917.

The steamboat era began and ended before the electronic navigational aids of radar and depth-finders appeared on the scene. In places, the river channel is narrow, and during the spring and autumn, fogs were frequent. As a result, some accidents did occur. There were incidents of collisions, groundings, boiler explosions, steamers destroyed by fire, and even some sunk as the result of ice. Although unfortunate and not particularly common, such events did add color and create interest in the period.

Of all the Hudson River steamboat companies, the best known was the famous Hudson River Day Line. This company operated the greatest number of boats, made landings at the principal cities, carried the most passengers, was probably the best managed, and operated during the daylight hours when its steamers were seen by the most people. Len Tantillo's portrait of the *Albany* shows it as it appeared in 1895 when, with a companion vessel called the *New York,* the two steamers were providing daily service (except Sunday) between New York and Albany.

The Hudson River steamboat operators greeted the twentieth century with great optimism. More passengers were using the steamers than ever before.

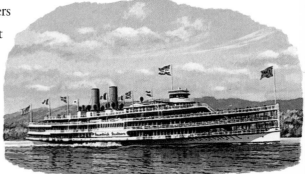

L.F. Tantillo, *Hendrick Hudson*
[1989] (William and Michele Keleher).

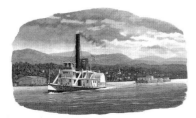

L.F. Tantillo, *Norwich* [1989]
(Michael B. Picotte).

During the new century's first decade, all the companies built or had planned the largest steamboats ever to be operated by them. The Hudson Navigation Company (Albany night line) in 1904 placed in service the first steamer to exceed 400 feet in length, the *C. W. Morse.* This huge vessel's name was changed to *Fort Orange* in 1922, and Tantillo's painting of this steamer shows it gracefully steaming on the Hudson in 1924, three years prior to retirement.

The Hudson River Day Line in 1906 placed in service a steamboat that was a distinct departure from its predecessors. The *Hendrick Hudson's* design, size, accommodations, and three-cylinder inclined engine (instead of the familiar single-cylinder, walking-beam type) made it a riverboat pacesetter in every respect. It was also licensed by the federal government initially to carry 5,500 passengers, at the time the largest number for any vessel anywhere.

The euphoria of the steamboat owners was relatively short-lived. By World War I, America's love affair with the mass-produced automobile was gaining momentum fast. As automobile ownership increased, the highways were improved to accommodate them. The mobility of automobile ownership dramatically changed the transportation and vacation habits of millions of people, and passage by steamboat took a sharp drop. At the same time, the motor truck, with its door-to-door pick-up and delivery, took away much of the steamboat's freight business.

One by one, the steamboat companies disappeared from the scene. The Catskill line ended its passenger operations in 1917; the company serving Kingston, Poughkeepsie, and Newburgh left the river in 1929; and the Albany night line said good night to daily service in 1937. Finally, the Hudson River Day Line terminated its daily New York and Albany service, with scheduled stops at upper river landings, at the end of the 1948 season. Ironically, the steamboat era over the Hudson's length, started by a man named Robert Fulton, ended on September 13, 1948, with the departure from Albany of a Day Line boat named the *Robert Fulton.*

*Roger Mabie is the author of many articles on Hudson River steamships and the former president of the Steamship Historical Society of America.*

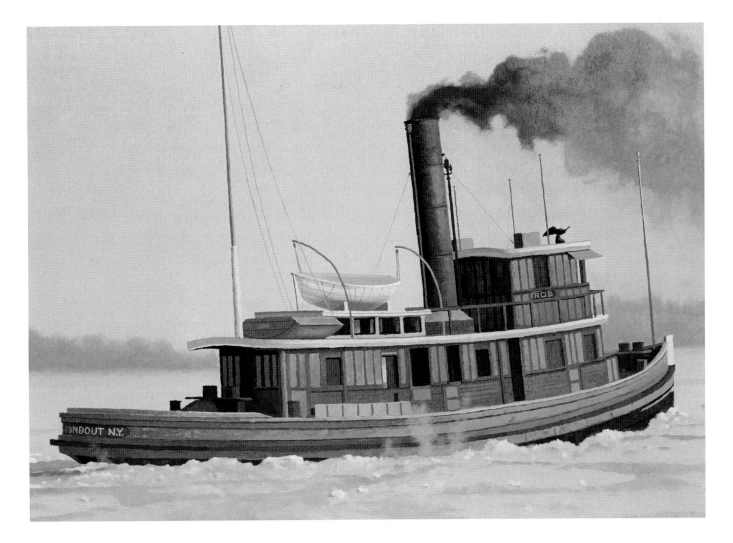

L.F. Tantillo, *The Rob* [1995] (artist's collection ).

The *Rob* was built in 1902 and served for 38 years on the Hudson River. It operated out of Rondout Creek, where it sank during an ice flow. The painting depicts the tug breaking ice in 1919.

On July 13, 1887, the *New York* made its first trial run. From the keel up, this was a dramatically new and modern ship. It was one of the first passenger steamers on the Hudson with a steel hull rather than an iron hull, making it much stronger and lighter than its predecessors. The boilers were placed forward of the engine and the paddle wheels aft. This was exactly the opposite of previous Hudson River dayliners and a configuration that contributed to the vessel's graceful appearance.

Another innovation was the use of feathered paddle wheels. Traditional fixed paddle blades pounded their way into the water and back out, wasting energy and causing substantial vibration to the vessel. Decks required massive, heavy timber reinforcement and cross-bracing. With the feathered design, the blades pivoted as the wheel turned. They would slice their way into the water smoothly, straighten out under water for maximum force, and exit as they had entered. The result produced a design that needed far less structural support and utilized its power much more efficiently.

The *New York* entered service on the Hudson River Day Line on July 18, 1887, joining its sister ship, the *Albany*. For many years, these two boats would depart every morning except Sunday from opposite ends of the river, pass each other around midday near Poughkeepsie, and arrive at six o'clock at New York City and Albany. The next day they would make their return runs.

Hundreds of thousands of people traveled on these steamboats every year. To accommodate the ever-growing numbers of passengers, the *New York* was modified in the fall of 1897. The vessel was cut in two and lengthened by 35 feet, making it a total of 335 feet long. The *New York* served the Hudson River Day Line for twenty-one seasons.

On October 20, 1908, just a few days after the last Albany run of the season, the *New York* was tied up at the Marvel Shipyard in Newburgh, awaiting minor alterations. Sometime around midnight, a small fire broke out near the kitchen. The vessel could not protect itself because it had no steam to operate its water pumps. Compounding the problem was the confusion of the fire companies that arrived at the scene. Initially, they could not find the right ship, and once the fire was located they did not have enough hose to reach it. By the time they

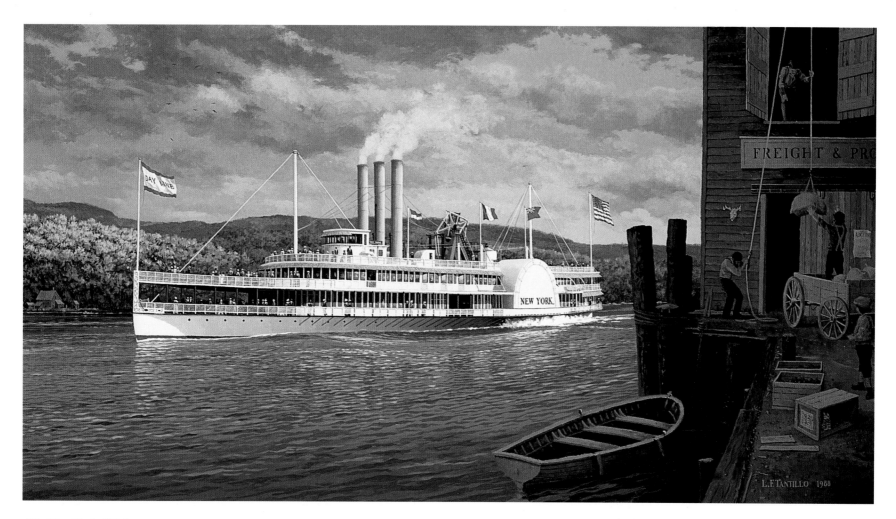

*The New York, 1895*

Acrylic on panel, 23.5 x 42 in.
Signed and dated lower right:
    L.F. Tantillo, 1988

COLLECTION
Michael B. Picotte

were set up it was too late. The flames spread quickly, destroying the *New York* and killing four members of the crew in their bunks. By morning, all that remained above the water after the disaster were the ship's stacks, walking beam, and paddle wheels. The engine and boilers were salvaged, repaired, and installed in a new dayliner, the *Robert Fulton,* which continued to ply the Hudson for nearly fifty more years.

The combined effect of its numerous unique features made the *New York* the sleekest, most well-proportioned steamboat ever built. The tool used to visually make this point in my painting was contrast. Black and white, sunlight and shade, old and new, large and small, even work and leisure—all serve to draw attention to the subject and influence the viewer's perception.

In the painting, the year is 1895, before the *New York* was lengthened. We are at the river's edge in Coxsackie, *New York*. In the foreground, the freight warehouse and its workers are totally in shadow. The afternoon has been stormy. In one magnificent moment the sun breaks through the clouds, illuminating the pristine white steamboat that glides into our view. In that brief instant, all that is required of us is to revel in the glory of nineteenth-century elegance.

THE SETTING:
This painting is set in Coxsackie
and depicts the *New York* north-
bound in the summer of 1895.

The *New York* was destroyed by
fire at a dock in Newburgh on
October 20, 1908. Four crew-
men were killed in the blaze.
The engines and boilers were
salvaged from the wreck and
reused in the Hudson River
steamboat, *Robert Fulton*.

# The Old Erie Canal

**W**hen the original Erie Canal was completed in 1825, it was 363 miles long, took eight years to build, and cost a little over $7 million. It stretched across western New York from Albany to Buffalo, passing through cities and towns, cow pastures, and woodlands. Its predecessor in 1798, General Schuyler's Western Inland Lock Navigation Company, utilized natural waterways, short canals, and locks to connect Schenectady with Oswego on Lake Ontario. The system did not extend far enough west and was inadequate to handle the growing cargo demands of the new republic.

Volume was exactly what the Erie Canal was designed to handle. Nowhere was this more dramatically illustrated than at Lockport, where five consecutive pairs of locks could lift or lower vessels a total of sixty feet in both eastbound and westbound directions simultaneously. In 1862, when the canal was enlarged, there were double locks constructed at every lift site. In 1918, most of the old canal was abandoned. The remaining short stretches were modified and incorporated into a much larger and more efficient waterway system known as the Erie Barge Canal.

In researching this project, I was struck with how quiet and peaceful travel on the old canal must have been in its latter years. Much of the route was through long stretches of uninhabited landscape, where the only sound might be the soft clopping rhythm of mule hooves on the dirt towpath. Many locks were not much more than a house for the lockkeeper and a barn for the livestock. Some rural locations had canal stores and rooms to rent. Travelers could get a home-cooked meal, rest for the night, and in the morning be on their way. One such place was Lock 33 at St. Johnsville.

In my painting, the sun has just set at the end of a warm summer day in 1895, leaving its faint red glow on the horizon. Lock tenders and crewmen maneuver a lightly loaded barge into one of the distinctive dual stone locks of the old Erie Canal. The towpath makes an enjoy-

L.F.T.

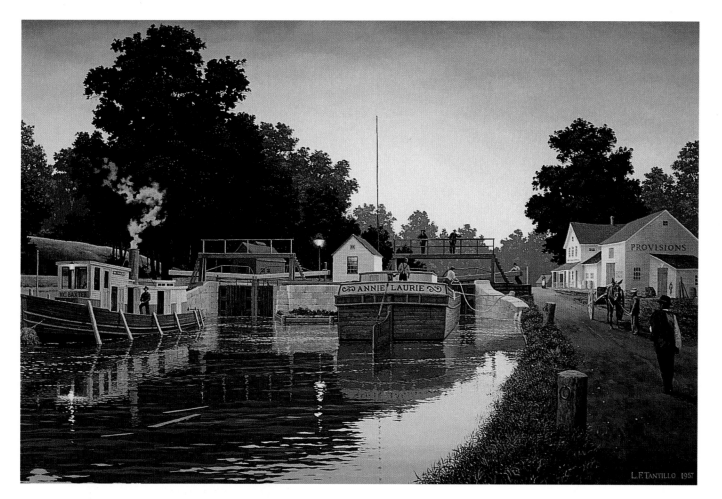

**The Old Erie Canal**

Acrylic on canvas, 26 x 40 in.
Signed and dated lower right:
L.F. Tantillo, 1987

COLLECTION
Wilson Greatbatch, Ltd.

able walk for the residents of the nearby village, especially on evenings such as this. The steady dull drumming sound of the steam tugboat's engine provides the tempo for summer's nocturnal chorus of peepers. A wisp of smoke lazily rises from its stack into the still evening air, as the shallow water in the canal reflects, mirrorlike, the cooling shades of the blue twilight sky.

While in England in 1986 (*above*) I visited numerous canal locks. Much of the British canal system has been well maintained, and the manual lock depicted in the photo is very similar to those used on the Erie Canal.

The photo to the right depicts Lock 33 at St. Johnsville, circa 1870. Note the height of the access bridge over the right lock and the intricate stonework details.

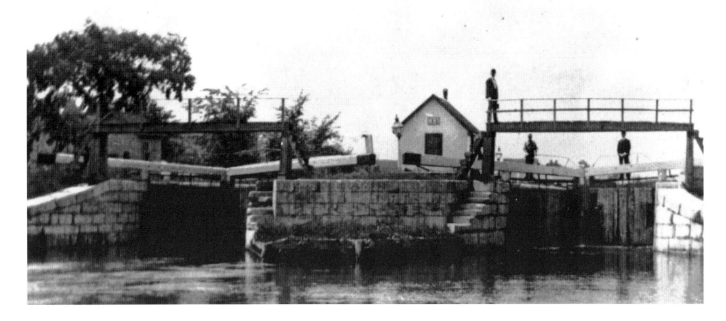

THE SETTING:
Lock 33 at St. Johnsville is located in the heart of the Mohawk Valley between Amsterdam and Utica. The old Erie Canal is long gone, and all that remains of this lock are a few cut stones in a grassy field, bounded by thick woods.

The circa 1860 photo (*above*) depicts the canal store and lockmaster's house at Lock 33. Facilities like this were common on the Erie Canal. Travelers could purchase provisions and get a home-cooked meal and a night's lodging, even at remote locations along the waterway. The mules that were used to pull barges were sheltered in adjacent barns.

Early in the project I made several plan-view sketches of canal locks. The drawing to the left depicts Lock 32 at Fort Plain.

*Adirondack Logjam*

Acrylic and panel, 24 x 36 in.
Signed and dated lower left:
   L.F. Tantillo, 1990

COLLECTION
Mary Carol and David White

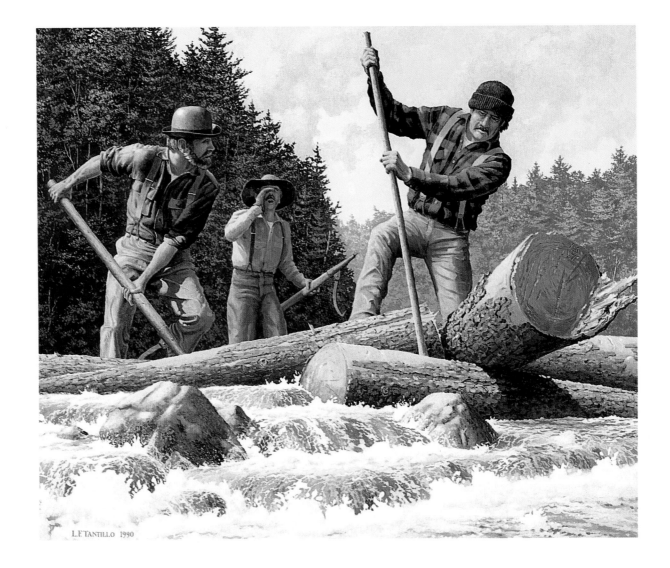

L.F. TANTILLO 1990

114

# Adirondack Logjam

The rapidly growing northeastern United States needed hundreds of thousands of board feet of lumber in the second half of the nineteenth century. The great virgin Adirondack forests of New York State were reduced to endless acres of stumps. Land management was ignored. Out of monumental mistakes such as clear-cutting, we learned valuable lessons. Replacement planting, planned harvesting, "forever wild" areas, and our overall environmental awareness are all products of our past errors. It is, however, very important to separate the poor planning of that time from the courageous, hardworking people who brought that wood to market.

Lumberjacks lived in crude logging camps. They were separated from their families for weeks at a time. Every working day they faced the possibility of injury and death. The work was hard and the pay was low. The premise of this painting was to salute their tenacity, courage, and strength.

The setting was to be springtime on the upper Hudson River in the 1890s; the subject, three figures attempting to dislodge a precarious logjam. Compositionally, the painting would be a series of intersecting lines. I wanted to use all the linear planes in the image—the men's arms, legs, and shoulders, the logging equipment, and the logs—to dramatize the entanglement of the jam.

The three models I selected were men who possessed the qualities that such a line of work would have required. In an action painting like this one, body language is extremely important. To get a pose right, the subject has to have a good imagination. Don Guarino (in the tan shirt) and Howard Lammerts (in the blue shirt) were able to get into character with a little direction, a few props, and a simple setup in my backyard. Mickey Conlee (in the red shirt), on the other hand, had trouble pretending that he was working on a pile of dangerously tangled logs.

A couple of days after our first unsuccessful session, I got a call from my friend Mickey explaining that he had found just the right location for the pose. Following his directions, I drove several miles up a rough back road. When I arrived at the scene, Mickey was already climbing to the top of a huge pile of fresh cut timber. He was wearing a knit watch cap, wide suspenders, a checkered shirt, jeans, and boots and was carrying a five-foot sawed-off rake handle. I didn't need to say a word.

Mickey Conlee posing as a lumberjack in a logjam.

# The Ticket Office

Beautiful architecture shelters our bodies and soothes our souls. It transcends language and culture, satisfies our senses, and at the same time fulfills particular spatial needs. It is a fading, if not dying, art in a world that places practicality and economy at the top of the design priority list. There is little room in the field of architecture today for the imagination of dreamers. What a strange phenomenon, indeed, that the most beloved buildings reflect exactly those characteristics our contemporary age rejects in new construction.

The Hudson River Day Line ticket office was constructed on Broadway in Albany, New York, in 1907. Most people could not guess in what year it was built, much less in which architectural style—they just know they like it. And even after nearly a hundred years of neglect, abuse, poor maintenance, and horrendous additions, its basic dignity still shines through. This building was born in an imaginative mind and time.

Walter Hunter Van Guysling had been working for Albany architects since he was sixteen years old. His early years of training were spent under the tutelage of the local master, Marcus T. Reynolds. Van Guysling apprenticed in a time of great artistic expression. Buildings were lavishly ornamented, steamboats of exquisite design crowded the Albany riverfront, and American artists were experimenting with an incredible variety of styles and subjects. In 1904, Van Guysling began a five-year association with Albany architect Charles Ogden.

Among Ogden's clients was the prestigious Hudson River Day Line. Badly in need of an upgrade of its building, the Day Line retained Ogden's firm for design proposals. Ogden assigned his young draftsman Van Guysling to the project. Borrowing elements from seventeenth- and eighteenth-century Dutch and Flemish architecture and interweaving some of his own unusual ideas, Van Guysling created a whimsical rendering of the Day Line building. Ogden presented the work to his client, it was accepted, and in 1907 the Van Guysling watercolor sketch became reality.

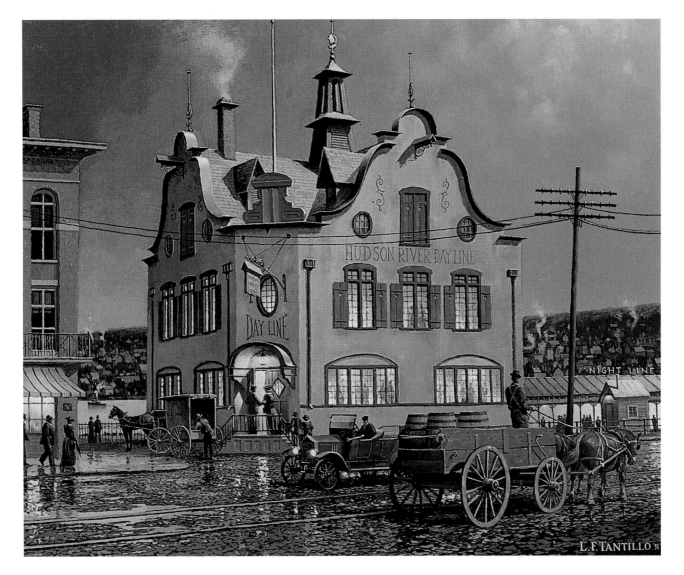

**The Ticket Office**

Acrylic on canvas, 16 x 20 in.
Signed and dated lower right:
   L.F. Tantillo, 1991

COLLECTION
The Hudson River Club

When I was commissioned by the Hudson River Club to paint the Day Line ticket office, it occurred to me that I would be working with a building that was extremely familiar. It had been painted and photographed numerous times and, unlike so many of my subjects, was still standing. How could I create a unique image that would capture the essence of Van Guysling's whimsical architectural statement?

After a series of studies, I became interested in the lighting possibilities of a night scene. The blue-gray sky, cool shades of green on the building's street facade, and wet cobblestones contrasted well with the warm lamp glow inside. Although those elements make up the essence of this work, the roof features were the most fun to paint. The subtlety of light and shadow, luxurious curves, spires, dormers, and central tower reinforced my belief that today, more than ever, we owe Van Guysling our gratitude. Thanks, Walter.

## Hudson River Day Line
### STEAMERS
Washington Irving — Robert Fulton
Hendrick Hudson — Albany
and DeWitt Clinton

**1921 DAILY INCLUDING SUNDAYS 1921**
Except as noted in individual items and EXCEPT HOLIDAY PERIODS
MAY 28, 29, 30—JULY 2, 3, 4, 5, and SEPT. 3, 4, 5, 6,
for which see special holiday time table
This Time Table is Subject to Change Without Notice
Service operated on Daylight Saving Time May 14th to Sept. 24th, One hour in
Advance of Eastern Time and on Eastern Standard Time Sept. 25th to Oct. 23rd.

| NORTH BOUND FROM | Through Service Daily, Including Sunday A.M. | Pough-keepsie Service Daily, Including Sunday A.M. | New-burgh Service Daily, Except Sunday A.M. | Sunday Only A.M. | Sunday Only A.M. | Saturday Only P.M. |
|---|---|---|---|---|---|---|
| New York | | | | | | |
| Desbrosses St... | 9 00 | ......... | 8 40 | 9 30 | 10 15 | 1 30 |
| West 42d St..... | 9 20 | 10 00 | 9 00 | F | | 1 50 |
| West 129th St... | 9 40 | 10 20 | 9 20 | F | ......... | 2 10 |
| Yonkers......... | 10 15 | 10 50 | 9 50 | | ......... | 2 40 |
| Bear Mountain... | A | 12 30 | 11 30 | 12 00 | 1 00 | 4 20 |
| West Point...... | B | d 1 00 | 11 50c | | | 4 50 |
| Newburgh........ | c12 30 | 1 40 | 12 40 | 1 00 | 2 00 | 5 30 |
| Poughkeepsie.... | 1 20 | 2 30 | | 2 10 | | |
| Kingston Point... | 2 15 | | | | | |
| Catskill......... | 3 30 | | | | | |
| Hudson.......... | 3 50 | | | | | |
| Albany.......... | 6 30 | | | | | |
| | P.M. | P.M. | P.M. | P.M. | P.M. | |

| SOUTHBOUND FROM | Through Service Daily, Including Sunday A.M. | Pough-keepsie Service Daily, Including Sunday P.M. | Bear Mountain Service Daily, Except Sunday P.M. | Sunday Only P.M. | Sunday Only P.M. | Sunday Only P.M. |
|---|---|---|---|---|---|---|
| Albany.......... | 9 00 | ......... | ......... | ......... | ......... | ......... |
| Hudson.......... | 11 15 | ......... | ......... | ......... | ......... | ......... |
| Catskill......... | 11 40 | ......... | ......... | ......... | ......... | ......... |
| Kingston Point... | 1 05 | ......... | ......... | ......... | ......... | ......... |
| Poughkeepsie.... | 2 00 | 4 30 | ......... | 2 20 | ......... | ......... |
| Newburgh........ | 2 50 | 5 30 | ......... | 5 20 | ......... | ......... |
| West Point...... | B | d 6 00 | ......... | ......... | ......... | 6 00 |
| Bear Mountain... | A | E | 5 30 | F | 5 30 | ......... |
| Yonkers......... | 5 00 | 8 00 | 7 30 | 7 50 | 7 30 | 8 30 |
| New York | | | | | | |
| West 129th St... | 5 30 | 8 30 | 8 00 | 8 20 | 8 00 | 9 00 |
| West 42d St..... | 6 00 | 9 00 | 8 30 | 8 50 | 8 30 | 9 30 |
| Desbrosses St... | 6 30 | | | | | |
| | P.M. | P.M. | P.M. | P.M. | P.M. | P.M. |

A —Boat stops 11.50 A.M. Northbound, and 3.40 P.M. Southbound, May 14th to June 10th and Sept. 12th to Oct. 23rd. B—Boat stops 12.10 P.M. Northbound, and 3.20 Southbound, daily except Sunday, May 14th to June 10th and Sept.12th to Oct. 23rd. c—Stops only to receive passengers July 6th to Sept. 2nd. d—Daily except Sunday. E—Stops 6.20 P.M. June 11th to July 2nd and Sept. 3rd to Sept. 11th. F—Stops Sundays only May 15th to June 5th and Sept. 18th to Oct 30th.
☞Over for Rates and Important Notes

# Syracuse and the New York Central

**David R. Gould**

Syracuse grew up around its railroads. In 1837 the village trustees decided that the railroad should run on the south side of the Erie Canal, and a station site at Vanderbilt Square on Washington Street, between Salina and Warren streets, was approved. By the end of June 1839, the station was home to the primitive trains of the Auburn & Syracuse and the Syracuse & Utica railroads. In short order, these two pioneer lines combined with eight other upstate rail lines to provide through service from Albany to Buffalo. By 1853 these lines had merged to become the New York Central Rail Road, the premier rail line of New York State and much of the northeast for nearly a century.

But as the city and the railroad grew, what was convenient in the mid-nineteenth century was barely tolerable by 1900 and downright unbearable by 1920. Consider the flood of trains. By the 1930s, 68 regularly scheduled trains passed east and west on Washington Street every day; add local switching moves and the average jumps to 90 train movements, with as many as 125 movements during peak holiday traffic. The effect of these trains, traveling at no more than fifteen miles per hour, at twenty-nine grade crossings through the city meant a continuous tangle of wagons, autos, trucks, and streetcars. Perhaps even more aggravating was the almost continuous shower of cinders and soot, which covered homes, vehicles, businesses, and pedestrians with gritty impartiality. Small wonder that a large crowd turned out to see the last train, the westbound Empire State Express, pass through Washington Street in September 1936 and to marvel at the new elevated station on Erie Boulevard.

The New York Central, the "water-level route" and home of the Twentieth-Century Limited and many other famous named trains, was once among the leading industries of New York State, commanding political and financial power in nearly every community. Its fleet of passenger trains captured the popular imagination and became the basis for Broadway plays and the inspiration for countless toy trains. Nothing better symbolized the power and drama of the New York Central Rail Road than its fleet of high-speed passenger locomotives. The Hudson type—named, like some other New York Central locomotives, for the rivers along which they ran—were built in Schenectady at the American Locomotive Company. They combined huge boilers with large drivers to become powerful, high-speed machines. First built in 1927, 275 were constructed in various sub-classes by 1937. Number 5222, pictured here, is emblematic of the railroad's once literal and figurative power.

Change has not been kind to the railroads of Syracuse. The once mighty New York Central is now but a part of freight-only Conrail; and Amtrak serves a modest passenger station in East Syracuse. The handsome 1936 station on Erie Boulevard hosts only buses, and the elevated right of way that ended the curse of grade crossings now carries a portion of the interstate highway. And the mighty Hudsons have all been scrapped.

# Washington Street, Syracuse, N.Y.

In 1988, I began a series of paintings for KeyBank. Each image depicted a city in New York State and focused on some historic feature that made the community unique. The paintings were large and complex, and they represented different centuries. The first was *The Return of the Experiment* (1787), and the second was *Buffalo Harbor, 1847*. From the onset of the third commission, a Syracuse scene, my search for a subject focused on the twentieth century. I started at the Onondaga Historical Society, and it didn't take long to find what I was looking for.

The 1930s were hardly a time of prosperity anywhere, and yet Washington Street was still one of the busiest thoroughfares in Syracuse. The Yates Hotel, First Trust & Deposit Company, and dozens of small shops selling everything from cigars to office furniture somehow survived those lean years of the Great Depression. The texture of street activity would have been considered "average" by any casual observer, had it not been for one very peculiar fea-

ture. Passing within a few feet of the storefronts, up to sixty-eight times a day, were the trains of the New York Central Rail Road. These were not trolley lines or intercity trains—they were the mainline tracks of one of the country's largest railroads. The vast majority of passenger and freight transit from New York City to Buffalo passed through the middle of Syracuse. The routing of trains on Washington Street began in 1839 and did not end until September 1936. It was said in the 1930s that there was never a time, day or night, when there wasn't a train on the street.

Unlike the previous works in the KeyBank series that represent little-known events and places, I would be painting an altogether familiar local subject. Literally dozens of excellent photographs depicting steam locomotives pulling New York Central trains through town were

*Washington Street, Syracuse, N.Y.*

Acrylic on canvas, 42 x 65 in.
Signed and dated lower right:
L.F. Tantillo, 1996

COLLECTION
KeyBank

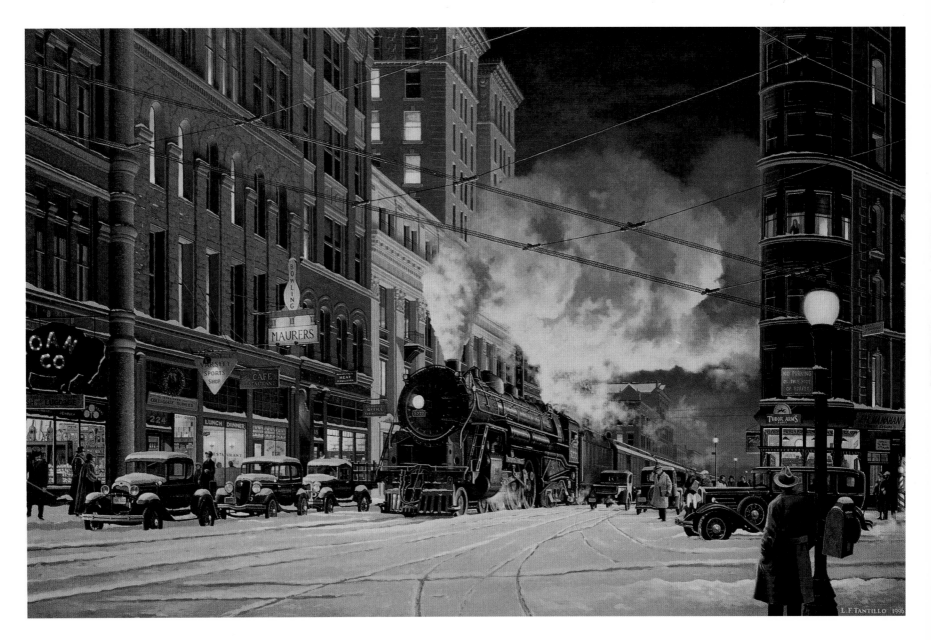

Bob Bouchard posing in my garage.

taken in the 1930s. What could I add to this subject that would be new and unique?

In addition to the physical differences between color paintings and black-and-white photographs, paintings possess infinite possibilities of light, shadow, and atmospheric tone. My first design decision was to depict the city at night, thereby maximizing the effects of these elements. Once that was established, the very nature of my setting and focal point led me toward an irresistible set of image components. Rather than fight the obvious, I pur-

sued it. Trains, snow, holidays, and nostalgia—I let it all happen. I never felt the image was trite. On the contrary, it seemed to emphasize the historical fact that New York Central trains ran through the middle of town. My underpainting was done in burnt orange and created a warm glow that seems to emanate from the entire image. That effect, combined with the upward direction of the storefront and street lights, produced a magical positive feeling that recalls some of our best urban experiences.

This photograph of present-day Syracuse was taken at the beginning of the project. Aside from landscaping, architectural renovations and the obvious absence of the Yates Hotel, this streetscape is much like it was in 1933.

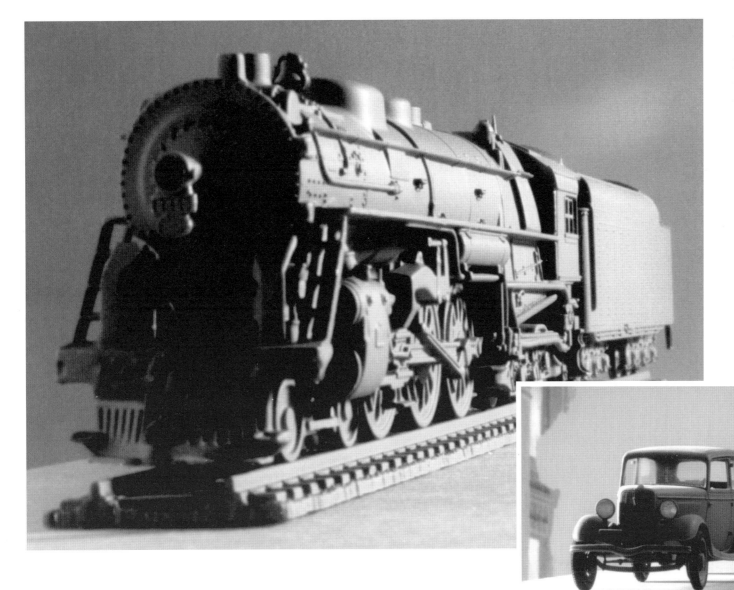

Over the years I have collected numerous and varied model kits, which I build as I need for projects. The plastic scale model (*left*) represents a J3 Hudson locomotive. In the painting, the New York Central engine that was in service at that time was a J1b. Since the frames of the two locomotives are similar, I was able, in the painting, to modify the details of the later version to represent its predecessor.

The two automobile models below are both Fords. The 1929 Model A ragtop pick-up is parked behind a 1933/34 Ford sedan.

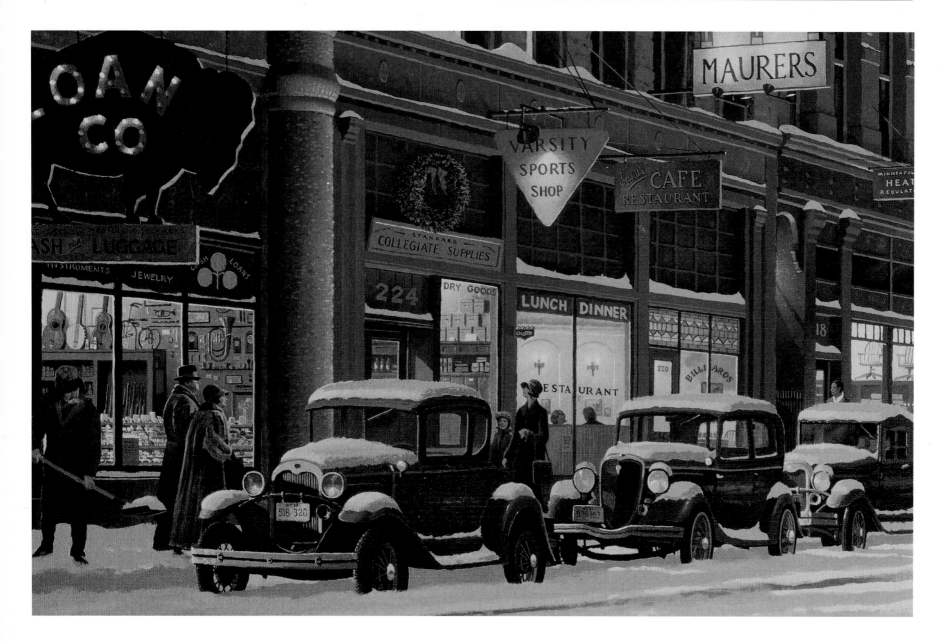

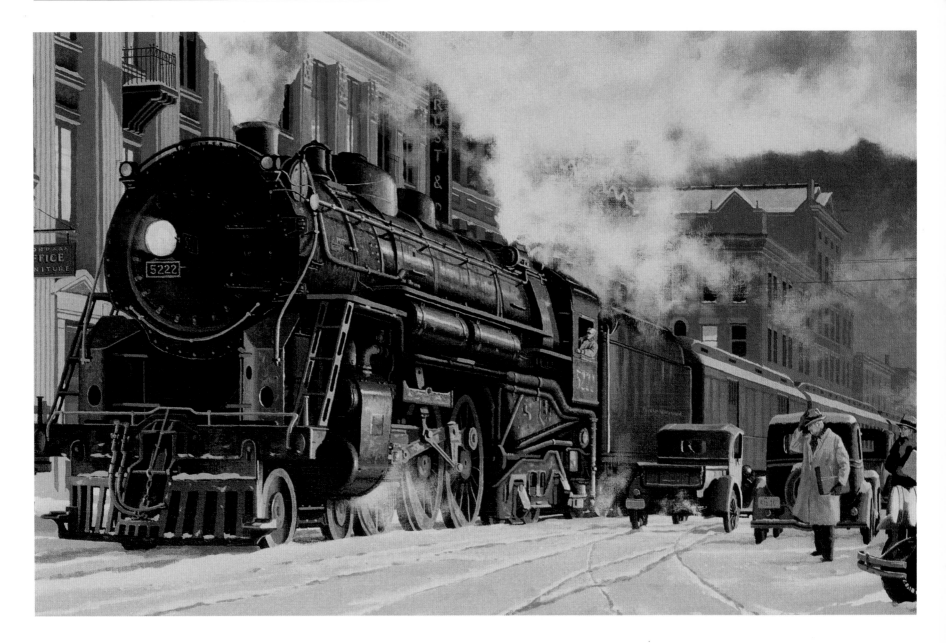

*Washington Street, Syracuse, N.Y.* ❧ 125

In this circa 1936 view of Washington Street, we are looking east. On the right side of the image, the foreground building in shadow is the First Trust and Deposit Company (now KeyBank). It was said in the 1930s that there was never a time, day or night, when there wasn't a train on this street.

216  Egry Register Co duplica-
        tors
      Ludwick Fredk J mfrs agt
      Onondaga Office Equipment
        Co Inc.
218  Nottingham Building
rm 403  Minneapolis Honeywell
        Regulator Co.
  "   409  Pratt A Granger printer
  "   503  Syracuse Towel Supply Co.
  "   511  Smith Wheeler A Co. Sport-
        ing Gds
220  Recreation Building
      Jewell Clarence H restr
      Macris Demetrius E baker
      Hess Henry K billiards
      Maurer's Bowling Alleys
224  Standard Collegiate Supplies
      Co. Inc.
228  Buffalo Loan Co.

This excerpt from the 1932 City Directory (*left*) indicates the names and addresses of businesses on Washington Street. I used this information when I painted the storefront signs.

The photograph below, taken in the late 1920s, shows the First Trust and Deposit Company currently occupied by KeyBank.

THE SETTING:
Washington Street is located in the middle of downtown Syracuse. Although there is little evidence today, the mainline tracks of the New York Central Rail Road ran through the middle of this street. Many thousands of trains traveling between New York and Buffalo and passing through Syracuse from the 1830s to the 1930s used those tracks.

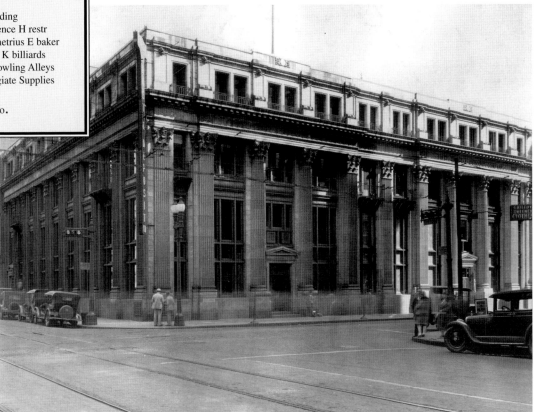

# The Whiskey Boat

rohibition brought a great thirst to the United States after 1919. Millions of parched throats sought relief. Home-made remedies from bathtubs and backyard stills could not ease the suffering of so many victims. It would take a miracle, but divine intervention from the clouds was not the elixir for which afflicted U.S. citizens were praying. In times of need, help so often comes from neighbors. Although kindness and generosity did not initiate the outpouring of assistance that flowed across the Great Lakes into New York State, there was, nevertheless, much gratitude.

Soothing the dryness of a country that had legislated the drought into existence in the first place was a tricky and dangerous business.

Kenny Boyd
posing as a bootlegger.

Rumrunners transporting Canadian whiskey into U.S. waters had no friends. The Coast Guard possessed both the authority and the firepower to ruin even the shortest evening cruise. Additionally, a rendezvous with unfamiliar customers could end in the loss of more than cash or contraband.

There were almost as many nautical techniques for coping with risks as there were smugglers and vessels plying the trade. Rumrunners came in every size and shape, from sailing ships to rowboats. Some bootleggers used sleek-hulled, customized pleasure boats with huge Packard engines that could outrun the "Feds" in an open-water chase. These boats were expensive and sacrificed cargo space for speed. What they lacked in practicality they made up in excitement. Others, representing a more practical element, used slow, steady workboats with com-

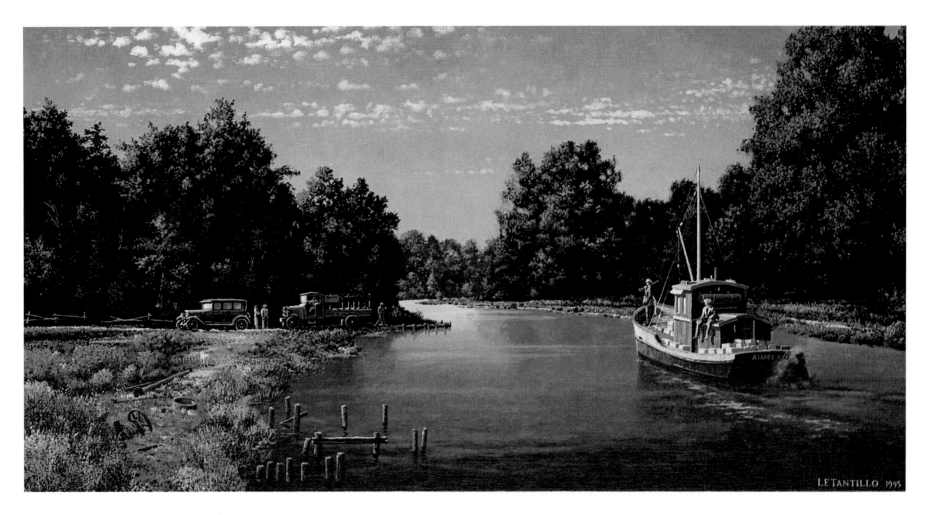

***The Whiskey Boat***

Acrylic on canvas, 30 x 40 in.
Signed and dated lower right:
  L.F. Tantillo, 1995

COLLECTION
Ami and Warren Greatbatch

129

THE SETTING:
This painting is set on the Burnt Ship Creek near North Tonawanda. There is no specific account of this site being used by smugglers during the years of Prohibition, although activity of this kind was common every-where along the U.S. and Canadian border, including the Niagara River, Lake Ontario, and Lake Erie.

I made this pencil sketch of a late 1920s Richardson general service boat from a simple model I built from ship's plans. Although a craft of this type was slow, it could carry a substantial cargo, making the risk of being caught worthwhile.

paratively large cargo holds. They were not quick, but a successfully completed run could yield substantial profits. My painting depicts the latter.

The shallow water of Burnt Ship Creek near North Tonawanda, New York, meanders inland from the Niagara River through mostly desolate countryside. In the middle of a summer night in 1932, an old Richardson general service boat with two armed guards on deck makes its way slowly toward a ramshackle dock. The *Aimee-Gee* sits low in the water; its muffled inboard engine is hardly audible above the familiar sound of night creatures. Faint wisps of smoke rise above the vessel's gur-

gling wake. Waiting on shore, a well-dressed man and woman stand next to a 1926 Cadillac, while two men carefully back a Buffalo stake truck into position. The rumrunner has been traveling under a cloudy sky most of the evening, but a light breeze has cleared the way for a full moon to coolly light the landscape. The peaceful scene carries an uneasy tension as the two parties prepare for their rendezvous. ✑

Andrist, Ralph K. *The Erie Canal.* Mahwah, NJ: Troll, 1964.

Barry, James P. *Ships of the Great Lakes.* Berkeley, CA: Howell-North, 1974.

Bennett, Allison P. *The People's Choice: A History of Albany County in Art and Architecture.* Albany: Lane, 1980.

Bielinski, Stefan. *Government by the People: The Story of the Dongan Charter and the Birth of Participatory Democracy in the City of Albany.* Albany: Albany Tricentennial Commission, 1986.

Bogaert, Harmen Meyrndertsz van den. *A Journey into Mohawk and Oneida Country, 1634–1635: The Journal of Harmen Meyrndertsz van den Bogaert.* Translated and edited by Charles T. Gehring and William A. Starna. Syracuse: Syracuse University Press, 1988.

Christoph, Peter. *A Norwegian Family in Colonial America.* Salem, MA: Higgens Book, 1995.

Doblin, Helga, and William A. Starna. *The Journals of Christian Daniel Claus and Conrad Weiser: A Journey to Onondaga, 1750.* Philadelphia: American Philosophical Society, 1994.

Dunn, Shirley W. *The Mohicans and Their Land 1609–1730.* Fleischmanns, NY: Purple Mountain, 1994.

Dunn, Shirley W., and Allison P. Bennett. *Dutch Architecture near Albany: The Polgreen Photographs.* Fleischmanns, NY: Purple Mountain, 1996.

Fontenay, Paul F. *The Sloops of the Hudson River: A Historical and Design Survey.* Mystic, CT: Mystic Seaport Museum Publications, 1994.

Kennedy, William. *O Albany! Improbable City of Political Wizards, Fearless Ethnics, Spectacular Aristocrats, Splendid Nobodies, and Underrated Scoundrels.* New York: Viking, 1983.

McEneny, John J. *Albany, Capital City on the Hudson: An Illustrated History.* Woodland Hills, CA: Windsor, 1981.

*Old Albany: A Pictorial History of the City of Albany.* Vol.1. Saratoga Springs, NY: Portofino, 1985.

Poortvliet, Rien. *Daily Life in Holland in the Year 1566: And the Story of My Ancestor's Treasure Chest.* New York: Harry N. Abrams, 1991.

Ringwald, Donald C. *Hudson River Day Line: The Story of a Great American Steamboat Company.* Berkeley, CA: Howell-North, 1965.

Ringwald, Donald C. *The Mary Powell: A History of the Beautiful Side-Wheel Steamer Called "Queen of the Hudson."* Berkeley, CA: Howell-North, 1965.

Snow, Dean R., Charles T. Gehring, and William A. Starna. *In Mohawk Country: Early Narratives of a Native People.* Syracuse: Syracuse University Press, 1996.

Staufer, Alvin F. *New York Central's Early Power, 1831 to 1916.* Medina, OH: Alvin F. Staufer, 1967.

Staufer, Alvin F. *Thoroughbreds: The Most Famous Class of Locomotive in the World, New York Central's Hudson.* Medina, Ohio: Alvin F. Staufer, 1975.

Verplank, William, and Moses W. Collyer. *The Sloops of the Hudson.* Fleischmanns, NY: Purple Mountain, 1984.

**T**hanking everyone by name who helped me in the fifteen years of work represented herein is not possible. There are, however, a few people I would specifically like to acknowledge for their help in my early career and with the publication of this catalog.

Art is my full-time job. It is an unpredictable, often difficult, and, at times, incredibly rewarding profession. I am absolutely convinced that if it weren't for the love and support of my amazing wife, Corliss, there would be no fine art career. For more than thirty years she has been my inspiration and my guiding light. Thanks, Cor, for shining so brightly and through so many storms. The warmth of that light powers my soul.

Since this is the family section of the acknowledgments, I would also like to thank our daughters, Wenonah and Edra, for their love, wit, and humor. Many of the paintings in this publication have benefited by their constructive professional comments. In addition I would like to thank my parents, Joseph and the late Emma Tantillo, for teaching me the important lessons of life; Leonard and Edna Robertson, for three decades of encouragement; my brother Joe for working so hard on the graphic design of this book; his wife, Maura Shaw, for the superb job of editing and organizing this publication; and my brother Anthony, a fisherman, who has taught me to know the true spirit of the Hudson River.

When I left the world of commercial illustration I embarked on a career filled with promise and uncertainty. In those very early days a good friend of mine, J.D. Gilbert, introduced me to Warren Greatbatch. Remarkably the two of us had much in common, and a friendship soon began. Warren asked me to paint his father's World War II aircraft, a TBF Avenger at Truk Lagoon. This was my first historical fine art commission. Since then we have collaborated on many projects, but I'm not sure if I ever told him how much that first one meant. Thank you, Warren, for building my confidence as an artist and thanks, J.D., for introducing us.

My first New York State historical painting was *The City of Albany, New York*. I began the research for this work without having the slightest idea of how much time it would take to complete it. But I was committed and somehow I was going to get the job done. After a couple of weeks of work, I received a call from Mike Picotte. Mike and I had been friends for a number of years and I had done some architectural renderings for his company. He had called regarding another matter. After some casual conversation, he asked me what I was working on. I explained that I was no longer doing commercial work and had started a painting depicting Albany in the 1860s. He asked if he could come out to see it and we set up a

meeting. When he arrived at the studio there was really nothing to view. The canvas was bare and white. I described the completed work that existed only in my mind, and Mike said he would like to buy it. Thank you for believing in me, Mike.

In 1989, I had the good fortune to meet Bob Bouchard, an enthusiastic lover of history and art. Bob liked my work and introduced me to Victor Riley. Victor thinks big and soon I was involved with monumental works for KeyBank. I thank them both for giving me the chance to explore the new territory of large-scale paintings and for the wonderful opportunity those projects unlocked in my career.

Many of my friends are historians. They believe as I do in the importance of knowing what came before. All of the work in this book is a result of their initial efforts. It is very rare that I begin a project without consulting one or more of these remarkable people. Many years ago Shirley Dunn helped me through a pen-and-ink drawing of the Philip Defreest House. I was impressed not only by her understanding of the subject but by how well she understood an artist's requirements for surface finishes and building details. Since then Shirley and I have collaborated on many projects. Charley Gehring has devoted his career to the study of the Dutch culture in the New World and is considered by his colleagues to be the pre-

eminent authority on this subject. With his generous participation he has influenced every work I've undertaken involving that era. Many thanks to Charley and also to Joe Meany, Dave Gould, Dean Snow, Craig Williams, Phil Lord, Bob Mulligan, Bill Starna, Janny Venema, Nancy Zeller, and George Hamill. I would also like to thank Paul Huey, whose thirty-year career as an archeologist for the State of New York has given him unique insights into the development and growth of this region. Paul has an international reputation and is considered to be one of the most knowledgeable overall experts on New York State history. A very special thank-you to my very good friend Steve Bielinski. Steve is a skeptic. We argue all the time. He is also a very talented historian. Although his area of study is colonial Albany, Steve has an impact on every project I undertake. I begin each project and almost continually wonder what he will find wrong with it. He makes me try a little harder and dig a little deeper, and for that and all these many years of close friendship I thank him.

Roger Mabie and I have collaborated on many projects. Roger is an authority on the subject of steamboats and other rivercraft; his early years were spent working aboard those marvelous vessels, and maritime adventure is very much in his blood. His family had plied the waters of the Hudson for several generations. Roger served as

commanding officer aboard three ships during World War II. His knowledge of the Hudson River has come from experience and scholarly studies. He is a great storyteller, and when we get into a project he can make it come to life in my imagination. I thank him for all his generous support and friendship.

I would like to thank all the sponsors who have so generously contributed to this exhibition and all the lenders who have kindly agreed to part with their works so that the public could have this opportunity to experience them.

A sincere and heartfelt thank-you to the University at Albany and President Karen R. Hitchcock for hosting this exhibition and supporting the publication of this catalog. Special thanks to the University Art Museum, specifically, the museum director, Marijo Dougherty. Marijo has been a close friend of mine for many years. She is a dedicated, open-minded woman who loves all art. Without her commitment this exhibition would not have taken place. The art world is a factionalized, intolerant place. Abstract expressionism, postmodernism, realism, and dozens of other categories clamor for attention. Marijo sees above the fray and offers audiences at the museum a balanced venue of artistic expression. I thank Marijo for giving me this wonderful opportunity to share my art with the public and for seeing the value of a body of work dedicated to history. I would also like to thank Zheng Hu for his superb exhibit design skills. His hard work and talent are very much appreciated. Additionally, I would like to thank Karen Engelke for giving so freely of her time, and Joanne Lue for seeing to all the day-to-day details.

I would like to extend my gratitude to the following individuals and institutions for making their rare and valuable collections available to me: the New Netherland Project; the Library of Congress; the New York State Museum; the New York State Library; the Holland Land Office Museum; Lester Wright; the Mystic Seaport Museum; the Onondaga Historical Society; the New York Historical Society; Morris Gerber; the Albany Institute of History and Art; the Buffalo and Erie County Historical Society; the Lower Lakes Marine Historical Society; Doug Haverly; the Buffalo Public Library; the Albany Public Library; Crailo State Historic Site; the New York State Bureau of Parks, Recreation, and Historic Sites; the Erie Canal Museum; and the Peabody Museum.

In closing I would like to thank every single person who ever patiently posed for one of my paintings, enduring bad weather and silly hats.

The following works, listed chronologically by the date of the subject depicted, comprise the exhibition entitled "Visions of New York State: The Historical Paintings of L.F. Tantillo," University Art Museum, University at Albany, State University of New York, September 7– November 3, 1996.

1600   *Mohican Dugout Canoe,* acrylic on panel, 1989. Christopher L. Anderson.

1609   *Daybreak on Hudson's River,* acrylic on canvas, 1986. L.F.T.

1609   *The Halve Maen,* acrylic on panel, 1989. Christopher L. Anderson.

1615   *Trading House,* pencil on tracing paper, 1995. L.F.T.

1615   *The Trading House, 1615,* acrylic on canvas, 1995. David A. Wolfe.

1625   *Winter in the Valley of the Mohawk,* acrylic on board, 1994. David A. Wolfe.

1625   *Winter in the Valley of the Mohawk,* acrylic on canvas, 1994. Victor and Lyn Riley.

1635   *Fort Orange* (aerial sketch), acrylic on board, 1986. L.F.T.

1635   *Fort Orange* (low angle sketch), acrylic on board, 1986. L.F.T.

1635   *Fort Orange, 1635,* acrylic on canvas, 1986. Michael B. Picotte.

1648   *Fort Orange and the White Whale,* acrylic on board, 1989. Charles T. Gehring.

1656   *De Eendracht,* acrylic on panel, 1989. Cheryl and Charles Fangman.

1660   *The Bradt Sawmill,* acrylic on panel, 1992. Kenneth Bradt.

1664   *Elias, 1664,* acrylic on panel, 1989. Thomas and Mary Rabone.

1686   *Signing the Dongan Charter,* ink on mylar, 1985. L.F.T.

1686   *Fur Traders,* ink on mylar, 1985. L.F.T.

1686   *Albany, N.Y., 1686,* ink on mylar, 1985. Stefan Bielinski.

1686   *Court Street,* ink on mylar, 1985. Stefan Bielinski.

1745   *The Van Alen House,* acrylic on panel, 1995. Mark and Kim Rossman.

1755   *The Defreest House,* ink on ragboard, 1982. Patricia Roberts.

1761   *The Saratoga,* acrylic on panel, 1989. Norman Bauman.

1778   *Gundelow,* acrylic on panel, 1989. Patrick and Mary Ann Mahoney.

1785   *Portrait of Stewart Dean,* acrylic on canvas, 1992. KeyBank.

1785   *Experiment,* acrylic on panel, 1989. Stefan Bielinski.

1786   *Voyage of the Experiment,* acrylic on canvas, 1992. KeyBank.

1787   *The Old Dutch Church,* acrylic on panel, 1992. James and Dolores Miller.

1787   *Portrait of Howqua,* acrylic on canvas, 1992. KeyBank.

1787   *Return of Experiment (layout preliminary #1),* acrylic on board, 1993. Robert and Mary Alice Bouchard.

1787   *Return of Experiment (layout preliminary #2),* acrylic on board, 1993. L.F.T.

1787   *Return of Experiment (color study #1),* acrylic on canvas, 1993. L.F.T.

1787   *Return of Experiment (color study #2),* acrylic on canvas, 1993. L.F.T.

1787   *Return of Experiment (houses),* ballpoint pen on paper, 1993. L.F.T.

1787   *The Return of the Experiment,* acrylic on canvas, 1994. KeyBank.

1795   *Nicoll-Sill house,* acrylic on panel, 1992. Pieter S. Vanderzee.

1807   *North River Steamboat,* acrylic on panel, 1989. Victor and Lyn Riley.

1809   *The State Capitol,* acrylic wash and ink on board, 1988. Lois and Stewart Wagner.

1813   *Quay Street,* acrylic on canvas, 1987. Patrick and Mary Ann Mahoney.

1814   *Schenectady Harbor (color study #1),* acrylic on board, 1992. Karen Engelke.

1814   *Schenectady Harbor (color study #2),* acrylic on board, 1992. Karen Engelke.

1814   *Schenectady Harbor, 1814,* acrylic on canvas, 1992. Karen Engelke.

1825   *Quay Street Study,* pencil on parchment, 1992. David and Barbara Van Nortwick.

1836   *Beaver,* acrylic on panel, 1989. Bruce and Ellen Allen.

1840   *Robert Wiltsie,* acrylic on panel, 1989. Robert and Mary Alice Bouchard.

1847   *Buffalo Harbor,* pencil on board, 1990. L.F.T.

1847   *Buffalo Harbor (color study #1),* acrylic on board, 1990. Robert and Mary Alice Bouchard.

1847   *Buffalo Harbor (color study #2),* acrylic on panel, 1990. Ami and Warren Greatbatch.

1847   *Buffalo Harbor (color study #3)* acrylic on panel, 1990. Victor and Lyn Riley.

1847   *Buffalo Harbor, 1847,* acrylic on canvas, 1990. KeyBank.

1852   *Steamboat Square (color study),* acrylic on panel, 1990. Lois and Stewart Wagner.

1852   *Steamboat Square,* acrylic on canvas, 1990. Francis H. Trombly, Jr.

1858   *Hoboken Hollow,* ink on mylar, 1980. L.F.T.

1868   *The City of Albany, New York,* acrylic on canvas, 1985. Michael B. Picotte.

1872   *Mary Powell (miniature),* acrylic on panel, 1989. Pieter S. Vanderzee.

1873   *Robert A. Forsythe,* acrylic on panel, 1989. Michael and Sharon Fernandes.

1879   *Griswold Wireworks,* ink on mylar, 1980. L.F.T.

1879   *Union Depot (color study #1),* acrylic on panel, 1992. Lois and Stewart Wagner.

1879   *Union Depot (color study #2),* acrylic on panel, 1992. Lois and Stewart Wagner.

1879   *Union Depot (color study #3),* acrylic on panel, 1992. Lois and Stewart Wagner.

1879   *Union Depot, 1879,* acrylic on panel, 1992. Lois and Stewart Wagner.

1880   *Norwich,* acrylic on panel, 1989. Michael B. Picotte.

1885   *Montauk,* acrylic on panel, 1989. David and Mary Smith.

1890   *Transport,* acrylic on panel, 1989. Corliss R. Tantillo.

1890   *The Mary Powell, 1890,* acrylic on panel, 1986. Michael B. Picotte.

1890   *The Pontiac, 1890,* acrylic on panel, 1986. Ami and Warren Greatbatch.

1893   *The Mary Powell at Rondout Creek,* acrylic on canvas, 1992. Richard and Ellen Whipple.

1893   *Engine 999 (color study & background),* mixed media, 1988. Ami and Warren Greatbatch.

1893   *Engine 999,* acrylic on panel, 1988. Wilson Greatbatch, Ltd.

1895   *The Old Erie Canal,* acrylic on canvas, 1987. Wilson Greatbatch, Ltd.

1895   *The New York, 1895,* acrylic on panel, 1988. Michael B. Picotte.

1895   *Albany (steamboat),* acrylic on panel, 1989. Michael and Sharon Fernandes.

1895   *Adirondack Logjam,* acrylic on panel, 1990. Mary Carol and David White.

1895   *Mary Powell at Rondout (color study #1),* acrylic on panel, 1992. L.F.T.

1895   *Mary Powell at Rondout (color study #2),* acrylic on panel, 1992. L.F.T.

1897   *30 Mile Point Lighthouse,* acrylic on canvas, 1996. David A. Wolfe.

1898   *Marion River (color study),* acrylic on board, 1991. Edra M. Tantillo.

1898   *Marion River, 1898,* acrylic on canvas, 1991. Ami and Warren Greatbatch.

1898   *Mary Powell in Transit (color study),* acrylic on panel, 1992. Wenonah K. Tantillo.

1910   *The Ticket Office (color study),* acrylic on panel, 1991. David N. Toussaint.

1910   *The Ticket Office,* acrylic on canvas, 1991. The Hudson River Club.

1910   *William F. Romer,* acrylic on canvas, 1992. Roger W. Mabie.

1912   *Storm King,* acrylic on panel, 1989. Patrick and Mary Ann Mahoney.

1914   *Hendrick Hudson,* acrylic on panel, 1989. William and Michele Keleher.

1919   *The Rob,* acrylic monochrome on panel, 1995. L.F.T.

1924   *Fort Orange (night boat),* acrylic on panel, 1989. Michael B. Picotte.

1933   *Whiskey Boat,* pencil on tracing paper, 1995. L.F.T.

1933   *Whiskey Boat (color study #1),* acrylic on board, 1995. L.F.T.

1933   *Whiskey Boat (color study #2),* acrylic on board, 1995. L.F.T.

1933   *Whiskey Boat (color study #3),* acrylic on board, 1995. L.F.T.

1933   *The Whiskey Boat,* acrylic on canvas, 1995. Ami and Warren Greatbatch.

1933   *Washington Street, Syracuse, N.Y.,* acrylic on canvas, 1996. KeyBank.

1938   *General Store (color study),* acrylic on panel, 1988. L.F.T.

1938   *The General Store, 1938,* acrylic on panel, 1988. Joseph Tantillo, Sr.

1938   *Comanche,* acrylic on panel, 1989. Ami and Warren Greatbatch.

1941   *Victoria,* acrylic on panel, 1989. Mary Carol and David White.

1957   *P&T Explorer,* acrylic on panel, 1989. Ami and Warren Greatbatch.

1982   *Mary Turecamo,* acrylic on panel, 1989. L.F.T.

1988   *Nile River,* acrylic on panel, 1989. Bill and Mary Ellen Siebert.

1988   *Bluestream,* acrylic on panel, 1989. Pieter S. Vanderzee.

1989   *Neptune Ace,* acrylic on panel, 1989. Pieter S. Vanderzee.

1994   *Canal Tug at Buffalo Creek,* acrylic on panel, 1995. Ami and Warren Greatbatch.

# I N D E X